Flowers

WONDERS OF NATURE IN WATERCOLOR

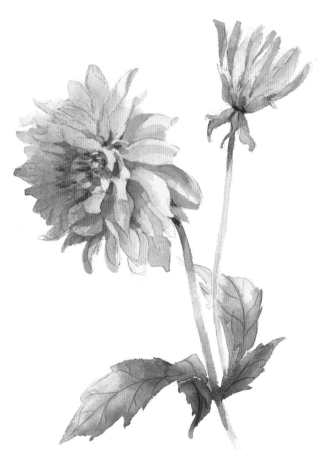

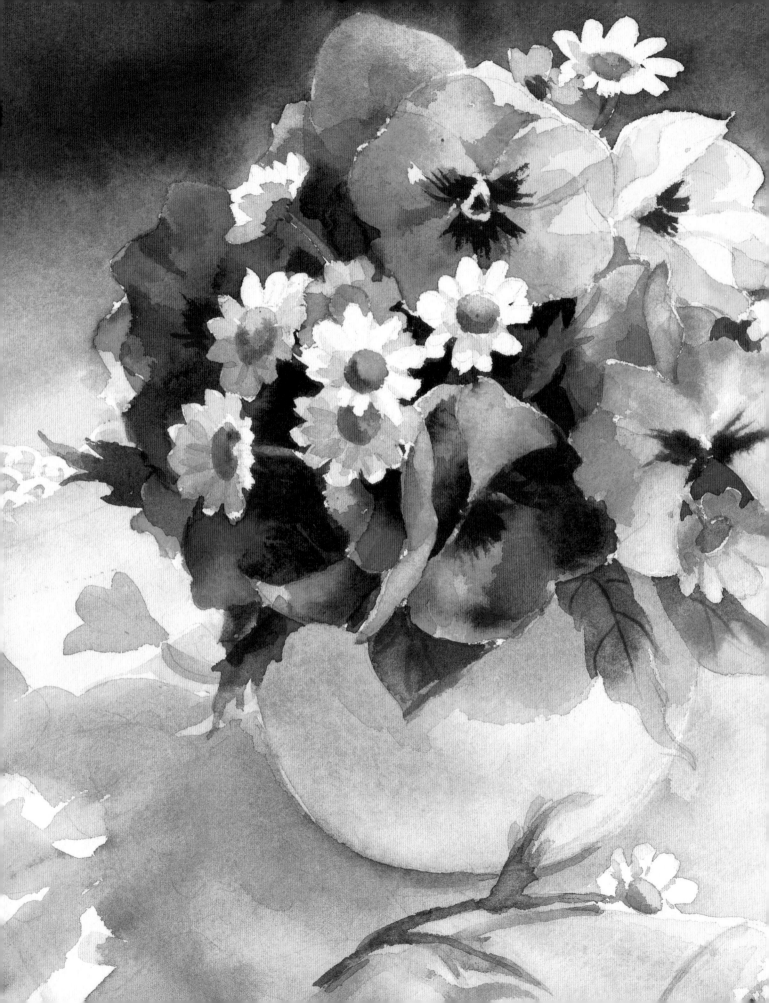

Flowers

WONDERS OF NATURE
IN WATERCOLOR

ERIKA JUST

WATSON-GUPTILL PUBLICATIONS
NEW YORK

Copyright © 2003 by Erika Just

First published in the United States in 2003 by
Watson-Guptill Publications
a division of VNU Business Media, Inc.
770 Broadway, New York, New York 10003
www.watsonguptill.com

Acquisitions Editor: Candace Raney
Editor: Meryl Greenblatt
Designer: Areta Buk
Production Manager: Hector Campbell

Library of Congress Control Number: 2003104064

ISBN: 0-8230-1853-9

Printed in the United Kingdom

First printing, 2003

1 2 3 4 5 6 7 8 9 / 11 10 09 08 07 06 05 04 03

● ABOUT THE AUTHOR

ERIKA JUST has studied with prominent and influential artists such
as Ed Whitney, José Perez, Robert Wood, and Bert Silberman. Her
work has been exhibited in galleries in America and Europe. She
currently lives in Weissenbach/Attersee, Austria, and can be reached
at www.erikajust.com or erika-just@web.de

● ACKNOWLEDGMENTS

I would like to thank Candace Raney and Meryl Greenblatt at
Watson-Guptill for their invaluable help and patience, and Areta
Buk for the lovely design of this book.

My gratitude also goes to Gene Chiappetta for his invaluable
advice and to Marge Brichler, who opened up a new world by
sharing with me her drawing skills and her great knowledge of
watercolor painting. Then there is José Perez. José is the greatest
living satirical painter in America. He helped me through the good
and the frustrating times with his genius and friendship. I would
not be a portrait painter had I not met him. My special thanks
belong to him.

● NOTES ON THE ART

FRONT COVER
Detail from *Nasturtium* (pp. 124–125)

FRONTISPIECE
Dahlia

TITLE PAGE
Pansies and Daisies, 13" × 19" (33 × 48 cm)

PAGE 6
A Short Visit, 15" × 11 1/2" (42 × 38 cm)

CONTENTS PAGE (CLOCKWISE FROM TOP)
Details from *Pink Dahlias* (p. 91), *Beauty of Little Things* (p. 87),
and *Flower of Gods, Flower of Love* (pp. 132–133)
Bluebonnets and Indian Paintbrushes
Pansy and Daisies

CHAPTER OPENERS
Details from:
Chapter 1: *Birthday Carnations,* 17" × 22" (43 × 56 cm)
Chapter 2: *A Summer Nosegay #2,* 17" × 22" (43 × 56 cm),
published by the United Nation's Children's Fund
Chapter 3: *Silver Dollar,* 11 1/2" × 15" (29 × 38 cm)
Chapter 4: *A Summer Nosegay,* 15" × 21" (38 × 53 cm),
published by the United Nation's Children's Fund

Except as stated otherwise, all art collection of the author.

To my dear Father, who gave me his talent,
to my darling son for his patience,
and with love to my wonderful husband,
who helped me to achieve my goals.

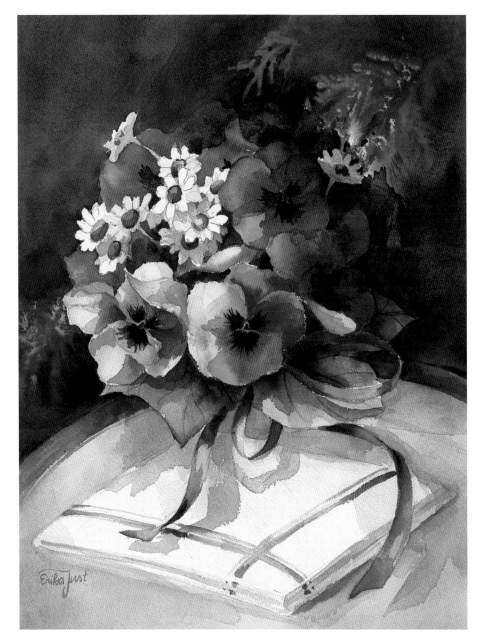

BOUQUET WITH BLUE RIBBON
14 $1/2$" × 11" (37 × 28 cm).

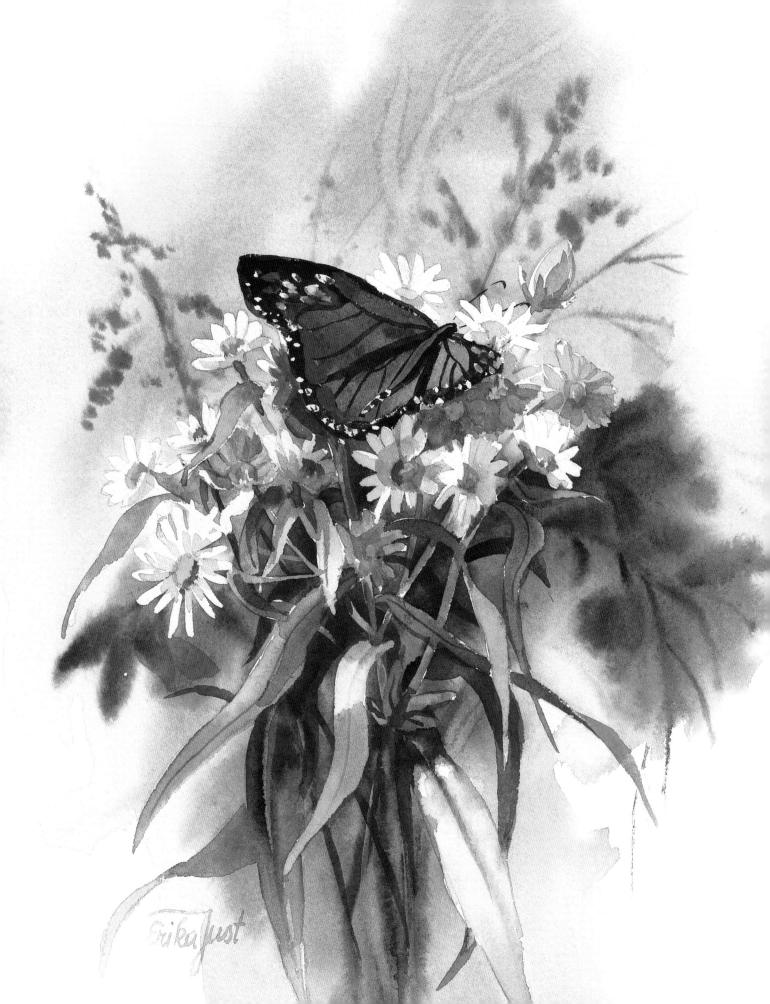

Contents

Introduction 8

CHAPTER 1

PAINTING MATERIALS 12

Brushes 14
Watercolor Paper 16
Palettes and Paints 20
The Color Star 22
The Temperature of Color 31
Color Selection 32

CHAPTER 2

PAINTING TECHNIQUES 34

Wet-in-wet 36
Conventional Painting 38
Lost-and-found Edges 40
Hard Edges 42
Creating Fuzzy Lines 44
Using Salt 45
How to Use Masking Fluid 48
Working with a Brush Handle 50
Stencils 52
The Translucency of Petals 53
Glazing Techniques 54

CHAPTER 3

HOW TO APPROACH A PAINTING 56

Knowing Your Subject 58
Leaves 62
Starting a Painting 64
Working from Photographs 68
Dramatic Value Limitations 69
Your Point of Interest 72
Checking Your Composition 74
When Is a Painting Finished? 78

CHAPTER 4

DEMONSTRATIONS 80

Beauty of Little Things 82
Pink Dahlias 88
Sunflowers 92
Tulips from Amsterdam 98
Clematis "Nelly Moser" 104
White Gladiolas 110
Irises 114
Nasturtium 120
Flower of Gods, Flower of Love 126
At the Edge of a Brook 134
After Christmas 140

Index 144

Introduction

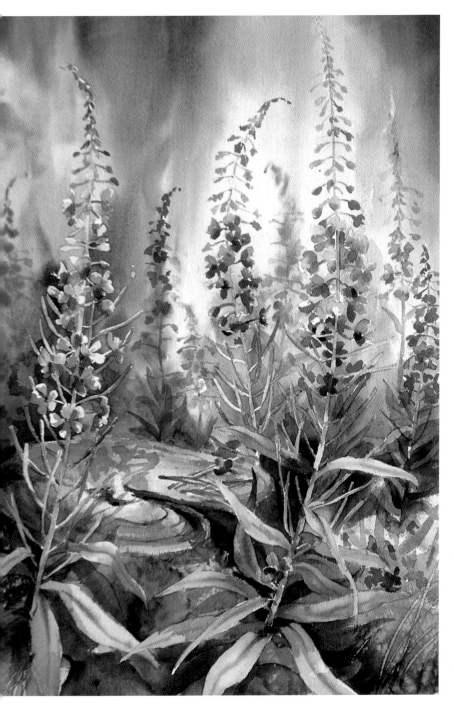

Flowers are miracles. It is fascinating to watch these lovely creatures as they grow out of the dark soil in their unrivalled beauty, but even more fascinating is the ability to re-create these miracles in vivid color on virgin paper.

FIREWEED
30" × 22" (76 × 56 cm).

Many people have never learned to see the beauty of flowers, especially those that grow unnoticed. For instance, when you walk outside and look down at your feet, you may see tiny flowers nestled in the moss and clover hiding under a curled fern. Most people just step on them. I paint them. An art critic wrote once: "Everything Erika Just paints turns into a portrait." He may be right, but it is not really my intention.

Most likely my ability to notice the little things was the result of my father's influence on me. I was born in Austria in 1937. As a little girl I could hear my father whistle from morning till evening, standing in front of his easel, painting one of his beautiful landscapes. I was fascinated watching his brush dance all over the canvas, mixing those brilliant colors and creating miracles. One night I got up and, with the imagination of a seven-year-old, painted three little birds into the blue sky of my dad's picture—just three little black dots. I never found out whether he liked it or not, or whether he even noticed, but the dots remained in the sky. That was the start of my painting career!

My school art teacher, a very sincere and earnest man, gave me bad grades because my colors would not stay within the lines of my sketch. But it was so much more beautiful to watch the colors blend freely than to bother with confining them within the drawing on my paper. My wonderful, dear father, instead of being angry, gave me my first and probably most important art lesson: "Lines are just little landmarks to help you along and tell you where you are and where you want to go. But they do not mean that you cannot detour and change your mind if you want to go somewhere else. If you try too hard to follow them, your painting tightens up and feels like a bird in a cage. So, give the painting the freedom it needs and watch carefully; it will tell you what it wants. By the same token, some lines might enhance

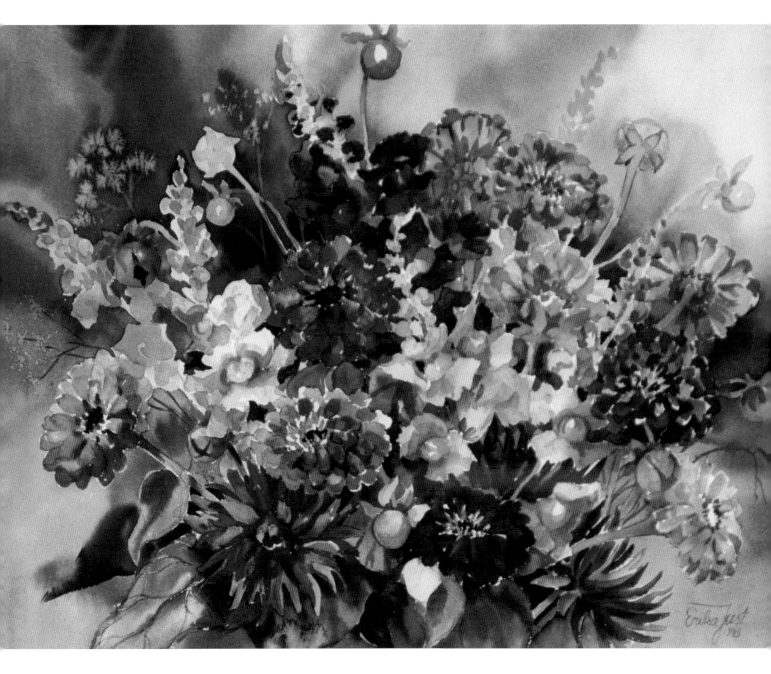

your painting and will give it strength where it is needed." I never forgot his words.

A few years later, a visit to the beautiful Kunsthistorisches Museum in Vienna left me in awe of many things: the fantastic works of art collected by the Habsburg emperors, the paintings by Rembrandt and Rubens, and every little bloom, bug, and butterfly in Brueghel's painted floral bouquets. What an incredible experience it was! After my whole being was filled with all the wonders I had seen I was determined to become a painter. And so I did. Fortunately, I married someone who traveled for his profession, giving me the opportunity to see and paint flowers and nature from all over the world.

Flowers are the ideal subjects to paint: they hold still for you while you paint them; they do not complain about a perceived lack of likeness; and they do not offer suggestions and comments on your color schemes or painting skills. However, painting flowers requires a great love of these "natural wonders" to do them justice. Careful attention to the principles of composition and design, an exquisite sense of light and color, and technical expertise are basic requirements.

ZINNIAS AND SNAPDRAGON
17 3/4" × 20"
(45 × 50 cm).
Published by the
United Nations
Children's Fund.

In this book I will demonstrate how to enhance your floral paintings, using various techniques. For example, how to bring out the exquisite translucency of white petals blushing into a soft pink when red ones lay just below; how to show the mutual reflections of different colors between adjacent flowers; and how to produce a lovely yellow glow when reflecting light touches a curving petal. The use of transparent watercolors as a painting medium can be an exciting adventure, but it can also be frustrating and difficult. The colors may develop a life of their own, moving and occasionally even seeming to thwart your efforts to control them. If the paper is too wet, colors go everywhere whether or not you intend it. If the paper is getting too dry, every new brushstroke or additional drop of water produces a fuzzy line or back run. Such incidents can emphasize your design if you are lucky, but they can also destroy your painting.

For instance, if you produce a "raspberry" or back run in a flower painting, it might stimulate your imagination and you might end up with a wonderful new shape. I always watch out for such potentially lucky accidents. The temperamental behavior of watercolor demands a better mastery of the mechanics and technical skills to control the medium compared to painting with oil.

Let me share my expertise with you and let us have fun as we travel together toward new horizons!

QUEEN ELIZABETH
11" × 12"
(28 × 31 cm).

CHAPTER 1

Painting Materials

Brushes

Years ago, when I started painting, I thought I had to own every brush I could get in the "Watercolor Brush" section of the art store. All those wonderful soft brushes in different shapes, sizes, and lengths would surely make me a good painter. I also bought many different styles of palettes and a variety of watercolor paper. The most positive result of my shopping binges was that I experimented with practically every watercolor paper on the market. Alas, most of the brushes are still laying untouched in my desk drawer. I was surprised how few I really needed.

When selecting your own brushes, the basic rule of thumb is pretty simple: For large areas use large brushes, for small areas use small ones. Since brushes hold various amounts of water, depending on the make, shape, and size, it is necessary to get used to each one individually. Once you have established the feel for a particular brush and determined that it meets those requirements necessary for your personal work habits, painting becomes pure pleasure.

The flat 3" brush holds a large amount of water, which is important especially when working on large size and heavy paper. I use it mainly for wetting the paper and, if I want to maintain my color flow for a longer period of time, for laying in a light colored background wash. Keeping the paper damp a little longer than usual gives me more time to place my colors, put in fuzzy lines or back runs, and create images of leaves and flowers.

For closer control I like to use the Winsor & Newton 1" flat, series 995 brush. Flat brushes have some advantages over round ones. You can lay in a large wash and follow up immediately with a fine line by turning the brush sideways, using either its full width or just its sharp corner. It's important, however, to use it in such a way that the painting never screams, "Hey look, somebody used a 1" brush on me!"

For more detailed, finer work, round brushes are preferable. Personally, I still favor sable for these brushes. I do not use many different sizes, so the extra expense is bearable. For my way of working, Kolinsky brushes are perfect. With a very delicate

Some of my favorite brushes. From top to bottom: #6 Kolinsky, #8 Kolinsky, #10 Kolinsky, #4 rigger, and #4 Kolinsky.

Your most important tools for painting with watercolor.

1" FLAT BRUSH
This Winsor & Newton brush is very versatile and the one I work with most often. Applied in just the right way, the paint will keep flowing without having to change brushes too often.

#10 ROUND BRUSH
When painting with round brushes, the numbers 10 and 8 are big enough for larger strokes and hold just the right amount of water.

#6 ROUND BRUSH
The numbers 6 and 4 are fine enough for smaller shapes, provided that their points are in good condition.

#4 RIGGER BRUSH
Holding this brush at the end of its handle, you can draw interesting and bizarre lines and shapes.

painting, I work with a small new round brush with undamaged bristles.

For fine lines and calligraphy I use a #4 rigger, a brush with extremely long hair.

Good brushes must hold a fair amount of water and must spring back into shape after each stroke. They should not be left soaking in the water and should be allowed to dry out in a horizontal position. Even if the fine tips are broken off, they are still usable for bolder brushstrokes. For delicate work, of course, it is better to use new ones. If you take good care of them, brushes usually last for a long time. I have used my 1" flat for about twenty years and it still looks like new—it seems to hold up forever.

Watercolor Paper

I have experimented with just about every watercolor paper on the market and come to the conclusion that only the very best quality paper is good enough for this purpose.

Good quality watercolor paper is made of 100% pure rag content. Bleached or unbleached fibers are transformed by a particular manufacturer's "magical process" into a sheet of watercolor paper with a surface delightful to paint on, which will remain beautifully white even when exposed to sunlight.

Lesser quality paper is made of a combination of wood pulp and rag, all the way up to 100% wood pulp, which is used as wrapping paper and for children to draw on in kindergarten or primary school. This type of paper is totally unsuited for transparent watercolors—it absorbs the paint unevenly and badly, and if exposed to light it will become yellow and crumble with age. If you practice on poor quality paper, you will have to relearn everything you thought you already knew once you start using high quality watercolor paper.

There are basically three types of watercolor paper: hot-pressed, cold-pressed, and rough. Each type has its advantages and disadvantages, and various brands will differ in quality. I prefer Arches 140-lb. or 300-lb. cold-pressed or rough paper, mainly depending on size and subject matter. I use hot-pressed paper if I want to do a wipe-out painting, or if I want to let interesting things happen on the surface. Arches is a strong, high quality paper that lets you change your mind if a drawing does not work and you have to erase or even do some scrubbing in the bathtub.

Fabriano cold-pressed paper has a wonderful velvety surface, but because of its softness, marks might appear if an eraser is used. Care should be taken to avoid brush-marks or puddles when laying in a graded smooth wash, since the paint dries more quickly on its smooth surface. Lightening areas and lifting paint with stencils is easier than on the rougher surface of Arches, where paint tends to remain in the little valleys of the paper.

NASTURTIUM
6¹/₄" × 5¹/₂" (16 × 14 cm).

HOT-PRESSED PAPER

Powerful presses squeeze the pulp at high temperatures to produce the hard, shiny surface of hot-pressed paper. Its surface is much smoother than that of cold-pressed paper, and therefore it absorbs less pigment. Most of the pigment remains on top of the paper, making hot-pressed paper ideal for lifting up paint and using stencils.

For my first wash on hot-pressed paper I like to use permanent dyes like Prussian blue, phthalo colors, Winsor blue and green, sap green, and so on. These colors will sink into the hard surface and dye it permanently. Afterward, I glaze over the dry paper, without lifting up the under-paint.

Hot-pressed is a fine paper for producing special effects. For example, by sprinkling water onto the damp paper by hand or with a spray can, terrific things will take place—all sorts of forms and shapes develop while the paper is drying.

SNAPDRAGON
14" × 11" (36 × 28 cm).

Brushstrokes painted on hot-pressed paper.

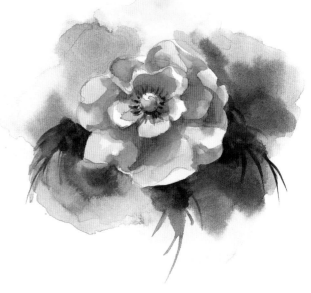

COLD-PRESSED PAPER

Cold-pressed paper is rougher than hot-pressed. I personally prefer cold-pressed, which has enough tooth to allow me to produce a great variety of effects through proper brush manipulation. Due to its higher degree of absorbency, a wash can be laid down more rapidly than on a smoother surface. You have to experiment over a period of time with different kinds of good quality paper to find out for yourself which surface works best for you.

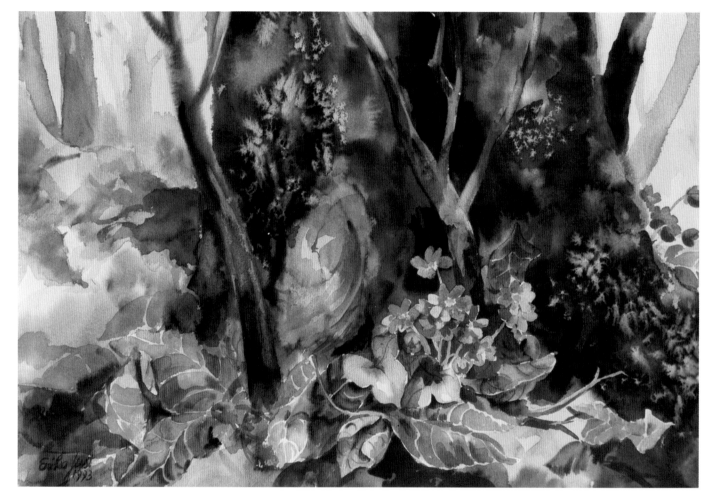

LITTLE BLUE TREASURE
17" × 22"
(42 × 55 cm).

Brushstrokes painted on cold-pressed paper.

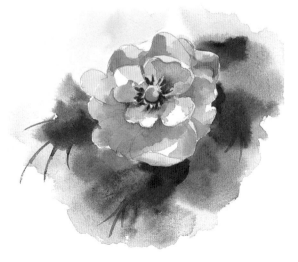

ROUGH PAPER

The little mountains and valleys on the surface of rough paper are tailor-made for stressing texture. As you move a loaded brush over the dry paper, pigment will adhere only to the tips of the rough edges; the white in the valleys below will therefore remain untouched. This technique will enhance the glittering of sunshine on a bright surface such as a glass bowl or on the petals of a flower but it takes practice. Try it out for yourself.

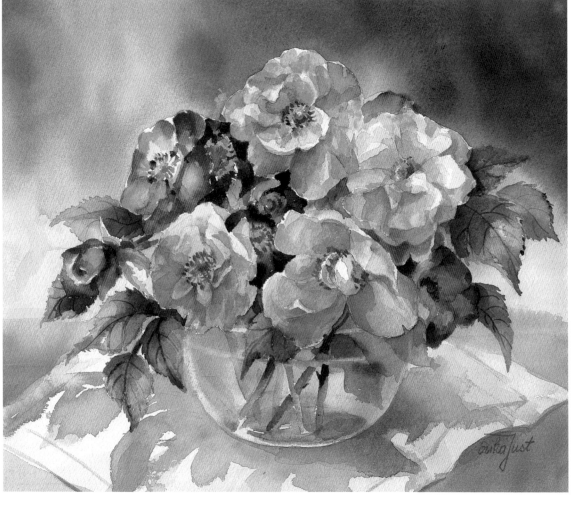

**GLASS BOWL
WITH ROSES**
11" × 14"
(28 × 36 cm).

Brushstrokes painted on cold-pressed, very rough paper.

Palettes and Paints

As I mentioned earlier, I have tried out many different palettes, some of which are now in the hands of my students. Palettes should be white and made of a nonabsorbent surface. They should also have deep enough wells to hold a large amount of paint, and have a lid that keeps the paint from oozing out and getting dusty. Which one you choose depends on your requirements and preferences. I use the John Pike palette for my basic colors. It is not the cheapest; however, it is durable and will last a lifetime.

For my more exotic and less-used colors I use other brands. Compare various palettes to find one that best suits your needs.

An artist's choice of paint colors is an expression of individuality and is unparalleled by any other element of design. The use of color and color relationship is a very personal matter involving the artist's eye, taste, sensitivity, experience, and intuition. In whatever direction artistic painting may evolve, color will always be the main means of execution. The intellect is touched by shape, the heart by color.

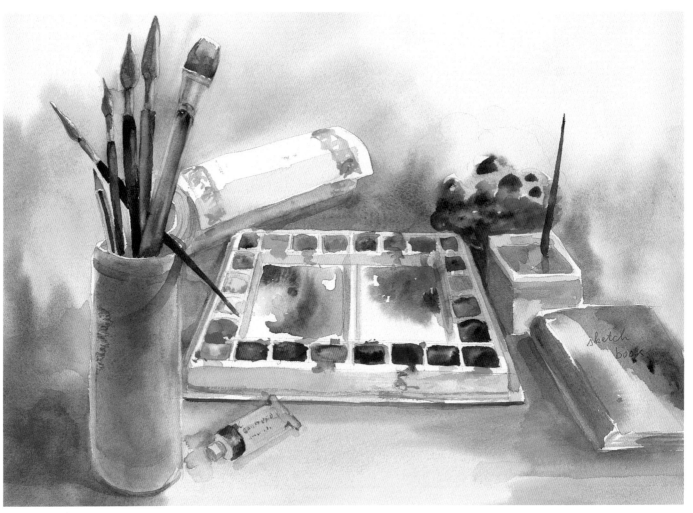

My personal palette.

Today, most companies are producing watercolors of excellent quality. I personally prefer Holbein, Winsor & Newton, or Schminke, organizing the colors on my palette so that the cool ones are on the left-hand side and the warm on the right. Using large tubes, I fill the wells to the rim with paint so that enough clean paint is left even if I dip a brush loaded with another color into it.

After some time the paint in each well will dry into a water-soluble hard cake, which is readily picked up again by rubbing a wet brush against it. However, if I want to pick up a larger amount of paint more quickly, I pre-wet the hardened paint in the well with a little water. This softens the paint again and my brush will pick up more pigment instantly.

I am not going to attempt a scientific treatise on colors in this chapter, as there are a number of excellent books available on that subject. Rather, I will simply try to explain the terminology and practical application of colors. You will see what I mean by "cooling down" an area of a painting or enhancing a subject by "warming it up," the ways in which various colors react to each other, and how, out of a relatively small number of hues, the most intense and brilliant colors can be mixed.

The fundamental words of the color vocabulary are hue, intensity, temperature, and value. Hue is the name of the color; intensity is its purity or grayness; temperature is its warmness or coolness; and value is its lightness or darkness. Black is a neutral color, which I prefer to mix myself because I am able to tint it either brown, blue, or green, depending on my preference at the moment. The same is true for gray. White consists of the entire visible spectrum. Over the years I have developed my own preferences for colors, which are represented on my main palette. Of course, this does not mean that I will never dip my brush into other more exotic pigments, kept on additional palettes.

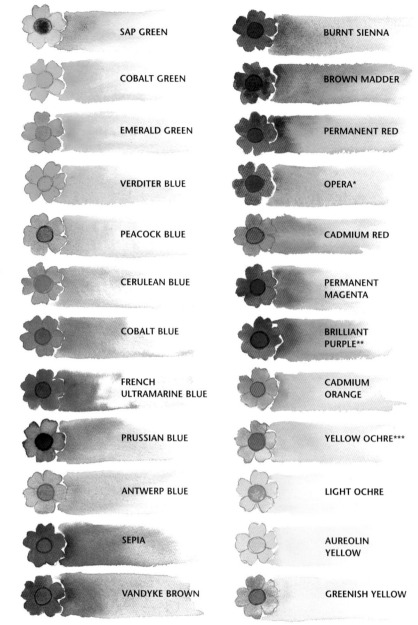

SAP GREEN

COBALT GREEN

EMERALD GREEN

VERDITER BLUE

PEACOCK BLUE

CERULEAN BLUE

COBALT BLUE

FRENCH ULTRAMARINE BLUE

PRUSSIAN BLUE

ANTWERP BLUE

SEPIA

VANDYKE BROWN

BURNT SIENNA

BROWN MADDER

PERMANENT RED

OPERA*

CADMIUM RED

PERMANENT MAGENTA

BRILLIANT PURPLE**

CADMIUM ORANGE

YELLOW OCHRE***

LIGHT OCHRE

AUREOLIN YELLOW

GREENISH YELLOW

● MY FAVORITE COLORS

*Opera from Holbein is a very bright and powerful color, which I use often but sparingly and seldom pure. If mixed with other colors like sap green, Vandyke brown, or any of the blues, it produces a very special underlying glow in the painting. Experiment with opera—you will love it! Its lightfastness is excellent. Some of my paintings have been exposed to sunshine for years, without noticeable changes.

**Because of its intensity and brightness I would never use pure brilliant purple on a landscape, but on a floral painting it could produce a beautiful accent.

***Winsor & Newton's yellow ochre can be lifted up again, whereas Holbein's yellow ochre is a permanent color and stains the paper.

The Color Star

The three primary colors—yellow, red, and blue—cannot be produced by mixing. Yellow is located at the top of the color star, red at its "warm" left side, and blue at its "cool" right side. Separating the primary colors are the three secondary colors: orange between yellow and red; purple between red and blue; and green between blue and yellow. Between the primary and secondary colors appear intermediate hues, which are called tertiary colors.

Moving counterclockwise from yellow to red, yellow-orange is made by adding a small amount of red to the yellow; adding more red creates the secondary color orange. Adding still more red creates red-orange, located above the primary color red. Continuing counterclockwise, a warm red-purple is produced by adding a small amount of blue to the red. Adding more blue creates the secondary color purple, while adding still more blue creates blue-purple, located at the left side of the blue primary color on the cool side of the color star. Continuing counterclockwise around the star, blue-green is produced by adding a little yellow to the blue. Adding more yellow creates the secondary color green, and adding still more yellow creates yellow-green, located to the right of the yellow at the top of the color star. The brilliance of the created hues is based on the clarity of the primary colors used.

The most intensive orange will develop by mixing permanent red or opera with permanent yellow or aureolin yellow. The most brilliant purple will result from a mix of cobalt blue or French ultramarine blue with opera, and the brightest green is made up of Prussian blue or Winsor blue with any yellow.

Complementary colors are located opposite to each other on the color star; for example, yellow is located opposite true purple. Mixing complementary colors produces subdued grayed colors, also referred to as earth tones. Note that the resulting color is influenced by the relative amount of each color used. For example, by applying a bit more blue-purple to yellow-orange the resulting color will tend more toward sepia than burnt sienna. And with more yellow-orange and less purple the hue will go further toward yellow ochre than burnt sienna. Mixing color is a very sensitive thing and just takes experimenting to find the right tone.

The best way to create the desired secondary, tertiary, and grayed hues is by using the trial and error method. Selecting an appropriate color scale depends to a large degree on the subject matter and the prevalent mood of the artist.

● A GUIDE TO MIXING COLORS

MIXING THESE COMPLEMENTARY COLORS	YIELDS	THESE SUBDUED GRAYED OR EARTH TONES
Yellow + purple	=	Yellow ochre + raw umber
Yellow-green + red-purple	=	Brown madder + alizarin
Green + red	=	Burnt umber
Blue-green + red-orange	=	Sepia
Blue + orange	=	Vandyke brown + sepia
Blue-purple + yellow-orange	=	Burnt sienna

PRIMARY COLORS

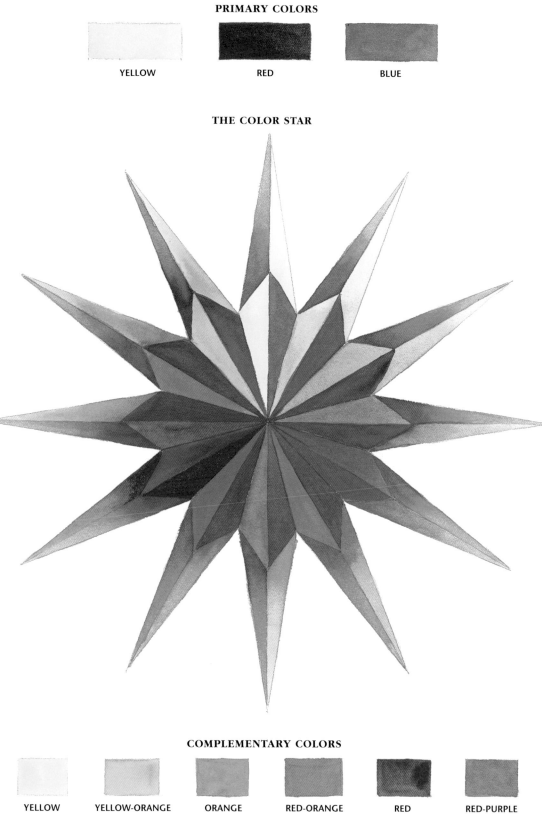

| YELLOW | RED | BLUE |

THE COLOR STAR

COMPLEMENTARY COLORS

| YELLOW | YELLOW-ORANGE | ORANGE | RED-ORANGE | RED | RED-PURPLE |

| PURPLE | BLUE-PURPLE | BLUE | BLUE-GREEN | GREEN | YELLOW-GREEN |

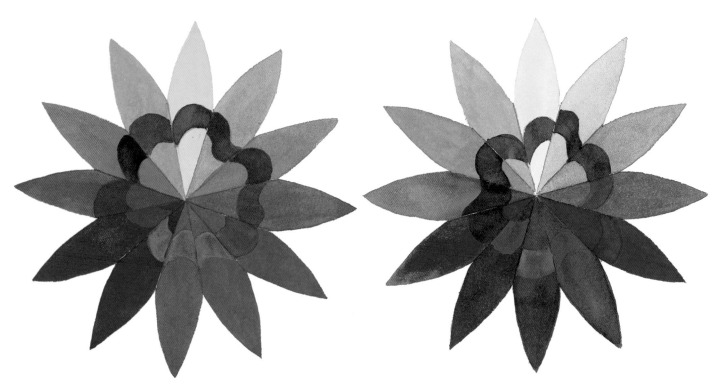

VARIOUS COLOR STARS

The first color star, above left, is done with permanent yellow, cobalt blue, and opera. The color opera is exceptionally transparent and produces secondary and tertiary colors and earth tones of outstanding luminosity. Only the greens appear somewhat muted because of the cobalt blue.

The second color star, above right, is composed of aureolin yellow, permanent red, and French ultramarine blue. These colors are not quite as brilliant. The purple is not a genuine purple, and the green appears a bit too earth colored.

The third color star, right, is a mixture of aureolin yellow, cadmium red, and Prussian blue. Most hues in this third star appear toned down. The purple is hardly recognizable, but the Prussian blue has made the greens quite brilliant and strong.

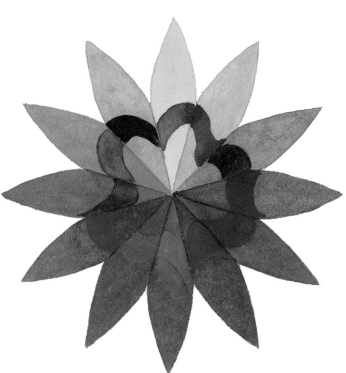

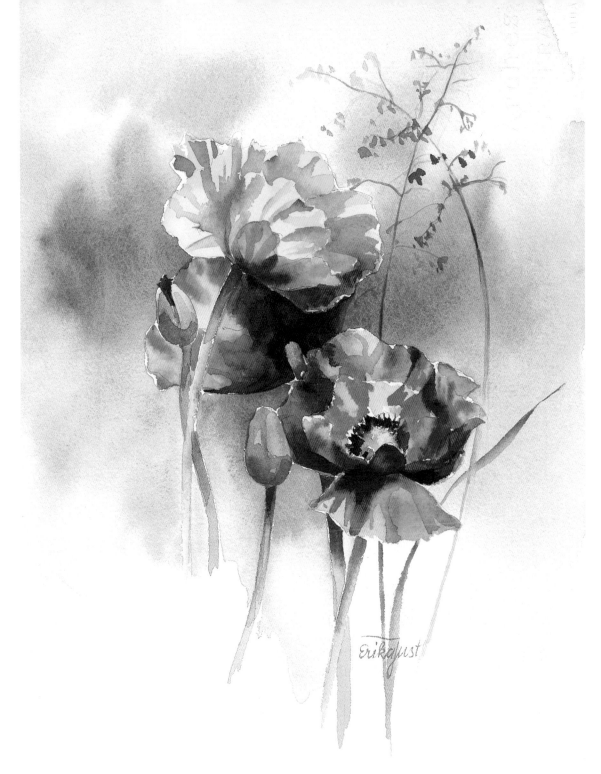

POPPIES
14$^1$/$_2$" × 10$^1$/$_2$" (37 × 27 cm).

This little sketch was painted using only the three primary colors. I could not make up my mind which of the yellow, blue, and red hues to use, so I used them all, making the undertaking all the more exciting.

The only exceptions were the darks in the centers of the flowers, where I had to add sepia and mix it with French ultramarine blue dark. Instead of using black, which is a dull "non-color," I like to mix sepia with other dark pigments. This way the darks glow and turn into green-black, brown-black, or blue-black, depending on the mixture, making them more interesting.

YELLOW + RED = ORANGE

This set of color swatches will give you an idea of how various colors blend on the paper.

In the first row, permanent red and opera blend almost evenly with aureolin yellow, while the aureolin yellow seems to spread little yellow roots into the alizarin.

In the second row, the same reds are blended with permanent yellow, showing almost identical results.

The third row shows an altogether different reaction. The yellow ochre is an opaque, nontransparent hue that seems to reject other colors, a peculiarity it shares with burnt sienna.

The colors in this set of swatches are identical to the ones shown above, with the difference that they were mixed on the palette. The resulting orange hues depend of course on the relative amounts of pigment used in the mix.

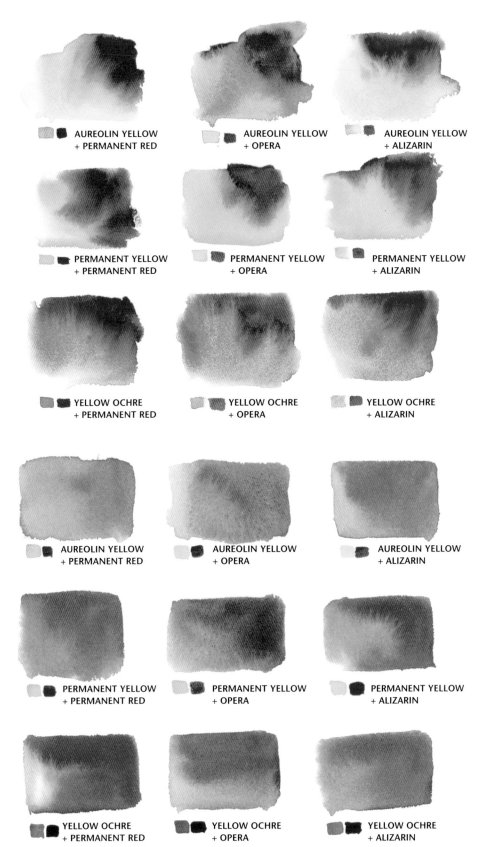

AUREOLIN YELLOW + PERMANENT RED

AUREOLIN YELLOW + OPERA

AUREOLIN YELLOW + ALIZARIN

PERMANENT YELLOW + PERMANENT RED

PERMANENT YELLOW + OPERA

PERMANENT YELLOW + ALIZARIN

YELLOW OCHRE + PERMANENT RED

YELLOW OCHRE + OPERA

YELLOW OCHRE + ALIZARIN

AUREOLIN YELLOW + PERMANENT RED

AUREOLIN YELLOW + OPERA

AUREOLIN YELLOW + ALIZARIN

PERMANENT YELLOW + PERMANENT RED

PERMANENT YELLOW + OPERA

PERMANENT YELLOW + ALIZARIN

YELLOW OCHRE + PERMANENT RED

YELLOW OCHRE + OPERA

YELLOW OCHRE + ALIZARIN

YELLOW + BLUE = GREEN

AUREOLIN YELLOW + WINSOR BLUE

AUREOLIN YELLOW + FRENCH ULTRAMARINE BLUE

AUREOLIN YELLOW + PRUSSIAN BLUE

PERMANENT YELLOW + WINSOR BLUE

PERMANENT YELLOW + FRENCH ULTRAMARINE BLUE

PERMANENT YELLOW + PRUSSIAN BLUE

Blending blue colors like French ultramarine blue and Prussian blue with yellow on the paper can create interesting effects. French ultramarine blue is a heavy pigment that tends to settle down into the little valleys of the paper, while the permanent colors Prussian blue and Winsor blue dye it. Winsor blue blends relatively smoothly and evenly with yellow.

YELLOW OCHRE + WINSOR BLUE

YELLOW OCHRE + FRENCH ULTRAMARINE BLUE

YELLOW OCHRE + PRUSSIAN BLUE

AUREOLIN YELLOW + WINSOR BLUE

AUREOLIN YELLOW + FRENCH ULTRAMARINE BLUE

AUREOLIN YELLOW + PRUSSIAN BLUE

The colors in this set of swatches are identical to the ones shown above, except that they were mixed on the palette. They demonstrate the importance of the blue hues in creating green colors. The most brilliant greens are achieved with Winsor blue and Prussian blue. French ultramarine blue and cobalt blue create a very subdued, almost grayish green that makes adjoining colors "sing."

PERMANENT YELLOW + WINSOR BLUE

PERMANENT YELLOW + FRENCH ULTRAMARINE BLUE

PERMANENT YELLOW + PRUSSIAN BLUE

YELLOW OCHRE + WINSOR BLUE

YELLOW OCHRE + FRENCH ULTRAMARINE BLUE

YELLOW OCHRE + PRUSSIAN BLUE

BLUE + RED = PURPLE

Creating a true purple or a tertiary purple by letting the colors blend on the paper depends on the relative amounts of pigment used and whether the colors in the mix are opaque or clear. The relative coolness or warmth of the purple hues is mostly determined by the blue colors.

The most brilliant purples can be mixed out of opera with either French ultramarine blue or cobalt blue.

The large and heavy pigments of the opaque cerulean blue tend to settle into the unevenness of the paper, creating interesting purple patterns.

**FRENCH
ULTRAMARINE BLUE
+ PERMANENT RED**

**FRENCH
ULTRAMARINE BLUE
+ OPERA**

**FRENCH
ULTRAMARINE BLUE
+ ALIZARIN**

**COBALT BLUE
+ PERMANENT RED**

**COBALT BLUE
+ OPERA**

**COBALT BLUE
+ ALIZARIN**

**PRUSSIAN BLUE
+ PERMANENT RED**

**PRUSSIAN BLUE
+ OPERA**

**PRUSSIAN BLUE
+ ALIZARIN**

**WINSOR BLUE
+ PERMANENT RED**

**WINSOR BLUE
+ OPERA**

**WINSOR BLUE
+ ALIZARIN**

**CERULEAN BLUE
+ PERMANENT RED**

**CERULEAN BLUE
+ OPERA**

**CERULEAN BLUE
+ ALIZARIN**

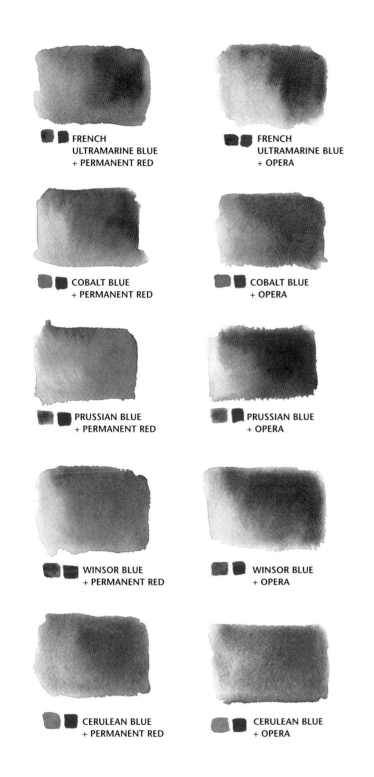

FRENCH
ULTRAMARINE BLUE
+ PERMANENT RED

FRENCH
ULTRAMARINE BLUE
+ OPERA

FRENCH
ULTRAMARINE BLUE
+ ALIZARIN

COBALT BLUE
+ PERMANENT RED

COBALT BLUE
+ OPERA

COBALT BLUE
+ ALIZARIN

PRUSSIAN BLUE
+ PERMANENT RED

PRUSSIAN BLUE
+ OPERA

PRUSSIAN BLUE
+ ALIZARIN

WINSOR BLUE
+ PERMANENT RED

WINSOR BLUE
+ OPERA

WINSOR BLUE
+ ALIZARIN

CERULEAN BLUE
+ PERMANENT RED

CERULEAN BLUE
+ OPERA

CERULEAN BLUE
+ ALIZARIN

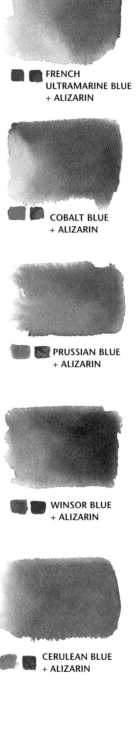

The colors on this page are identical to those on the facing page, with the difference that they were mixed on the palette.

YELLOW + RED + BLUE = EARTH TONES

Earth tones are created by mixing the three primary colors. The resulting hues and their warmth or coolness depend on the relative amounts of pigment used in the mix. Different yellows, reds, and blues produce various earth tones.

**AUREOLIN YELLOW
+ PERMANENT RED
+ WINSOR BLUE**

**AUREOLIN YELLOW
+ OPERA + FRENCH
ULTRAMARINE BLUE**

**AUREOLIN YELLOW
+ ALIZARIN
+ PRUSSIAN BLUE**

**PERMANENT YELLOW
+ PERMANENT RED
+ WINSOR BLUE**

**PERMANENT YELLOW
+ OPERA + FRENCH
ULTRAMARINE BLUE**

**PERMANENT YELLOW
+ ALIZARIN
+ PRUSSIAN BLUE**

**YELLOW OCHRE
+ PERMANENT RED
+ WINSOR BLUE**

**YELLOW OCHRE
+ OPERA + FRENCH
ULTRAMARINE BLUE**

**YELLOW OCHRE
+ ALIZARIN
+ PRUSSIAN BLUE**

The colors in this set of swatches are identical to the ones shown above, with the only difference that they were mixed on the palette.

**AUREOLIN YELLOW
+ PERMANENT RED
+ WINSOR BLUE**

**AUREOLIN YELLOW
+ OPERA + FRENCH
ULTRAMARINE BLUE**

**AUREOLIN YELLOW
+ ALIZARIN
+ PRUSSIAN BLUE**

**PERMANENT YELLOW
+ PERMANENT RED
+ WINSOR BLUE**

**PERMANENT YELLOW
+ OPERA + FRENCH
ULTRAMARINE BLUE**

**PERMANENT YELLOW
+ ALIZARIN
+ PRUSSIAN BLUE**

**YELLOW OCHRE
+ PERMANENT RED
+ WINSOR BLUE**

**YELLOW OCHRE
+ OPERA + FRENCH
ULTRAMARINE BLUE**

**YELLOW OCHRE
+ ALIZARIN
+ PRUSSIAN BLUE**

The Temperature of Color

Temperature, which means the warmth or coolness of colors, is relative. A hue that seems to be very "hot" on its own appears less so when put beside an even hotter color. This chart demonstrates how the apparent temperature of a hue is affected by its neighboring colors. The colors in the center column appear cool, compared with the colors on their left, and warm, compared with the ones on their right. The colors in the second row appear cooler against those above them and warmer compared with those below them, which in turn appear warmer than the colors in the bottom row.

CADMIUM RED	WINSOR RED	ALIZARIN
MAGENTA	MANGANESE VIOLET	WINSOR VIOLET
YELLOW GREEN	SAP GREEN	HOOKERS GREEN
PERMANENT SAP GREEN	WINSOR GREEN	PRUSSIAN GREEN

FOR THE YOUNG BRIDE
11" × 15" (28 × 38 cm).
Private collection.

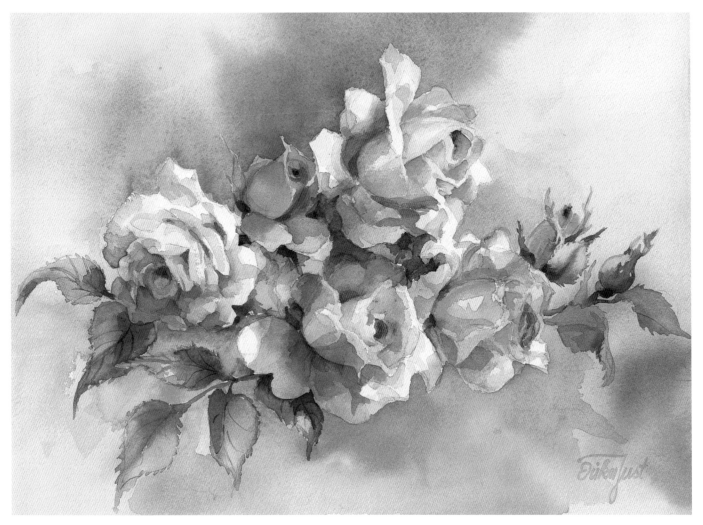

Color Selection

Sometimes, while I am still in the planning stage, picturing a painting's atmosphere and mood, I put together a color chart on a large sheet of paper and mix hues as the heart desires. This makes it easy for me to come up with the right temperatures and values and prevents uncertainties at a later stage.

Considering that all colors derive from just three primary colors, the variety of hues is overwhelming. The darker and more intense the color, the more caution is necessary during the mixing process. Almost everybody has experienced how much water is needed to dilute red in order to achieve a delicate pink, and how little water is required to lighten up yellow. Practice and experience help us put the right colors on the paper without much trouble.

BOUQUET WITH PINK ROSES
15" × 11" (38 × 28 cm).

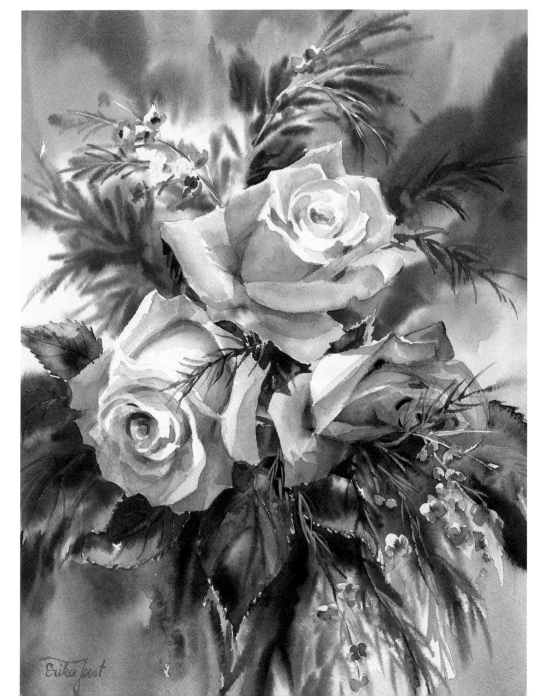

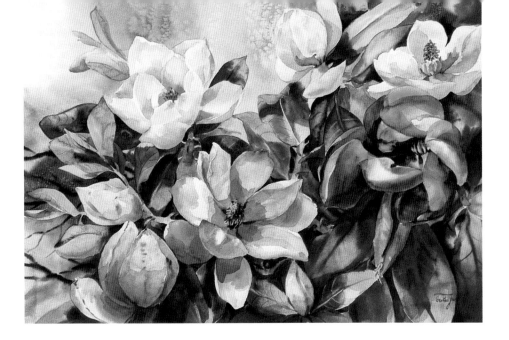

WHITE MAGNOLIAS
22" × 30" (56 × 76 cm).

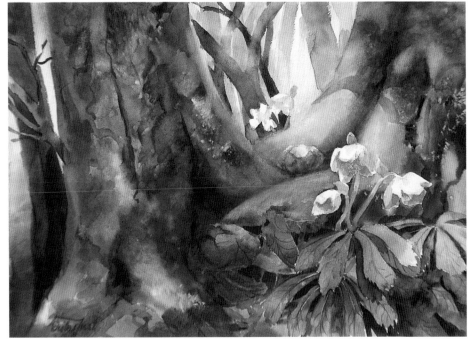

HIDDEN TREASURES
17" × 22" (42 × 55 cm).

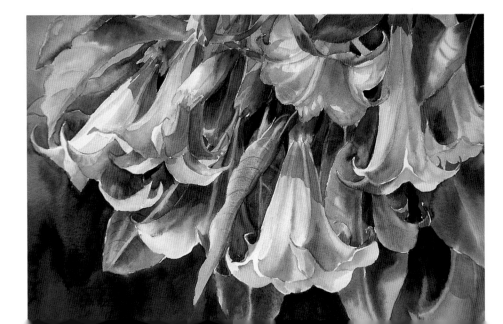

ANGELS TRUMPETS
15" × 22" (38 × 56 cm).

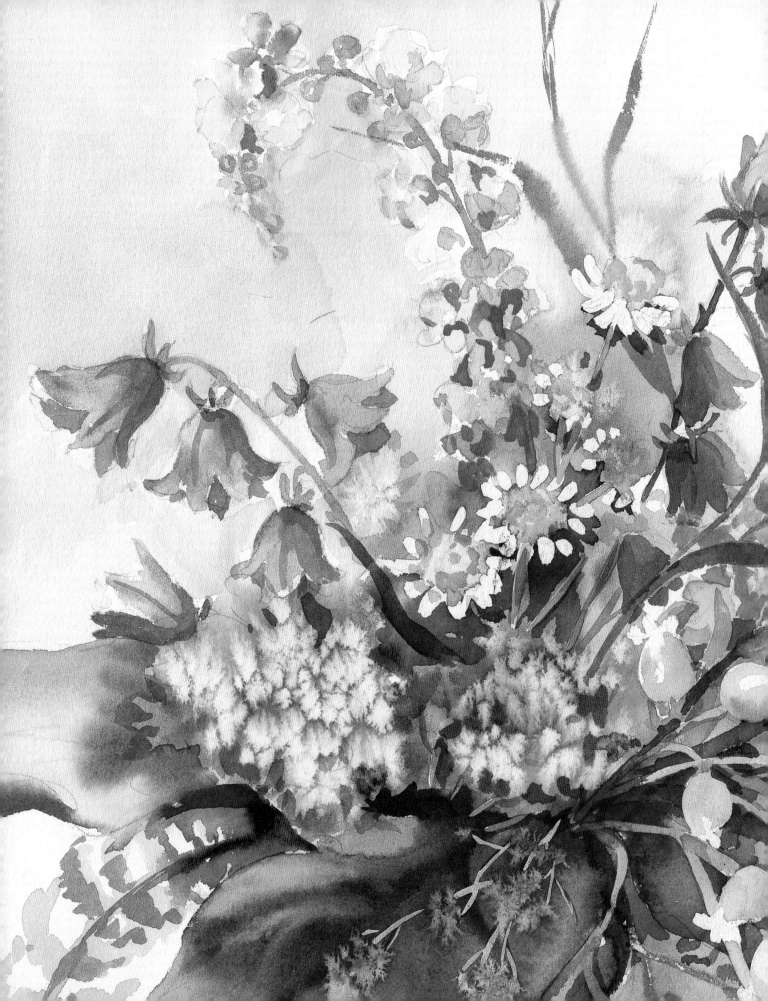

CHAPTER 2

Painting Techniques

Wet-In-wet

Ed Whitney, a great master of the wet-in-wet technique, painted beautiful, soft landscapes under cloudy skies, with misty trees lost in the scenery. With his soft brushstrokes he produced the most wonderful effects.

To do a blurred wash with soft edges, the paper must be soaking wet. I usually dip it in the bathtub and let it soak up as much clear water as it takes. Then I put it on a wooden board and wipe the excess water off its surface carefully, using a soft, damp, natural sponge. Next I apply a light colored wash, adding intensity and hue as the work progresses. There is no need to rush, as long as the paper is still wet and shiny, but care should be taken that the brush is not too heavily loaded with water, or the color will spread like an uncontrollable genie.

As the paper begins to dry, later brushstrokes will become either continuously less blurred, or beautiful back runs will appear. This would be the moment to paint fuzzy lines (see page 44) or use salt (see page 45) if desired. When painting flowers I use the wet-in-wet technique primarily for the background.

Once the paper is dry, it is time to start working on the details. To show diversity and contrast, sometimes the blossoms need crisp edges on the main area and soft edges around it. In the painting *Chinese Peonies* (see page 40), I added shapes of leaves to the soft background by painting dark leaves directly, and created light colored leaves by painting around them.

Practice and experience will teach you how much paint and water to apply to the wet paper to achieve the desired results. A good way to practice is to work simultaneously on a number of postcard-sized pieces of paper, as I did when I started painting watercolors. It was just before Christmas and I needed cards, so I cut an Arches 140-lb. cold-pressed sheet into eight pieces, placed them side-by-side on the table, wet them all at the same time, and painted one after another as fast as I could. It was easy to see how much softer the first card appeared, as compared to the last. I added the details after the papers were dry. The sooner you are able to control this moody medium, the more fun and satisfaction you will have.

HIBISCUS
14 3/4" × 19"
(36 × 48 cm).

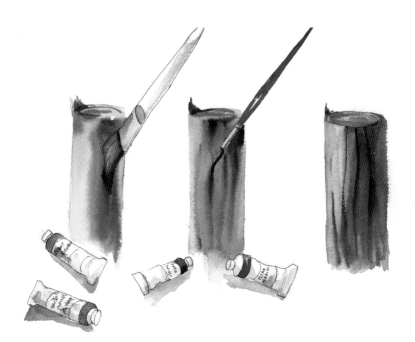

● WOODEN POST

Aged wood shows beautiful colors and textures. The best approach to bringing that out is by using the wet-in-wet technique. Keeping in mind where the light comes from, I put down the first wash with ochre and burnt sienna, using some cobalt blue to give it an aged appearance. Before the paper dried out, I added veins and cracks in the wood with sepia.

● ROCKS WITH MOSS

The visual impression of soft moss with its little stars is best achieved by using the wet-in-wet technique and by the application of a few grains of salt, as demonstrated in this sketch. The top of the rock was done with burnt sienna, ochre, and verditer blue. For the moss, I put a mixture of sap green and French ultramarine blue onto the still-wet paper, letting the two colors mingle. As soon as the paper had the right dampness, I sprinkled a few grains of salt onto the dark pigment. Every little grain of salt produced a little star. Using a smaller brush with some sepia, I drew the lines indicating the cracks in the rock.

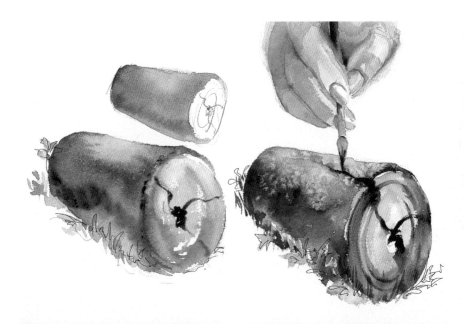

● TREE TRUNK

Using the wet-in-wet technique again, I applied the first wash using aureolin yellow and sap green. I then added some sepia to the dark side of the tree, which mixed nicely with the sap green. The contrast between the dull sepia and lighter green makes the moss appear to glow. Next, I added salt, which picked up the sepia pigment only. I then painted the fresh saw cut on the face of the trunk with ochre and burnt sienna to emphasize the warm hues of the wood. I indicated the decay with blue, and the cracks in the wood with sepia. In combination with bold brushstrokes on dry paper, exciting effects can be achieved, creating more interesting and diverse paintings.

Conventional Painting

Many people paint by using the conventional, or direct, painting method. Working in sections and finishing every flower or leaf separately before starting on the next one makes it easier to control the paint. It also allows more time to think, a luxury not enjoyed when painting wet-in-wet. Covering the whole sheet of paper with paint all at once is known to have caused the occasional bout of panic among the best of us. Using the conventional painting method, small sections are touched directly with the loaded brush, while larger areas are prewetted before color is dropped in and allowed to mingle on the paper. Separately painted shapes should blend with each other harmoniously; none should appear to stand out on its own. Hard edges can be softened with a wet brush. If adjacent colors require it, for example, when the warm glow of a tulip is reflected on a neighboring leaf, pigment can always be added by glazing over a finished area. The background is usually painted last.

The final results of both wet-in-wet and conventional painting techniques are equally beautiful, depending on one's skill and preference. I like the contrast between them, and can achieve my best results by both letting the colors spread over the sheet of wet paper as well as putting them down on dry paper.

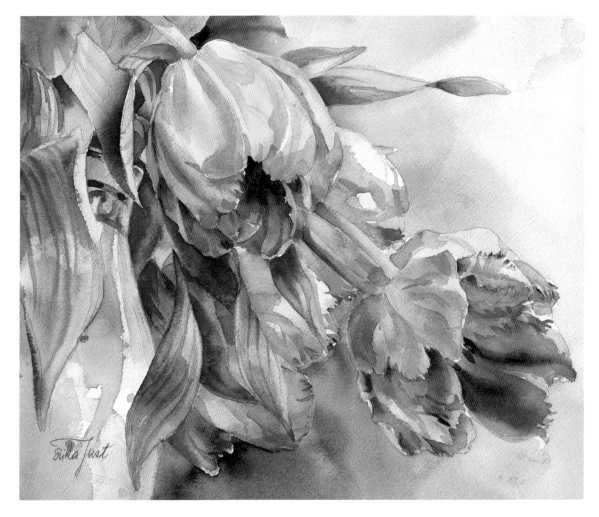

PARROT TULIPS
11" × 15"
(28 × 38 cm).

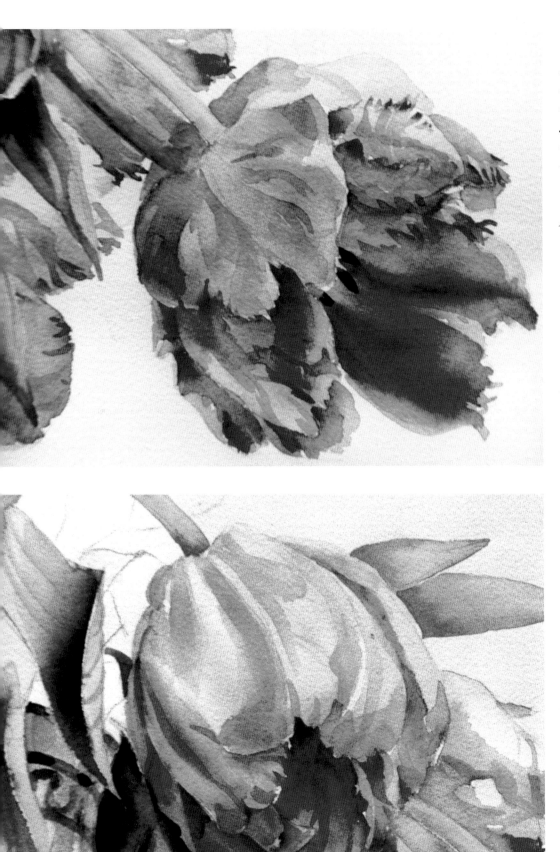

PARROT TULIPS, DETAIL

This detail shows the many different hues of this vividly colored tulip with its red and orange petals. The green of the adjoining leaves and stems reflects on their silky surfaces. The highlights, reflecting the bright light, are the white of the paper. "Painting with watercolor seems to be quite easy," a student once remarked to me. "One does not paint the light, one just leaves the paper white." (He did change his mind in due course.) Using the conventional painting method, I gave each petal a first wash. By glazing over the dry wash with some swift brushstrokes, I attained the crisp silky appearance of the petals.

PARROT TULIPS, DETAIL

Using the same procedure on the leaves and vase, I gave the leaves direction with graphic brushstrokes. Where the vase curves into the background, I softened the edge to give it a spherical semblance. The dark leaves with their soft edges blend together with the darker petals in the background. The brushstrokes must be crisp and spontaneous to achieve the fresh look that is so desirable in watercolor.

Lost-and-Found Edges

Lost-and-found edges enhance variety, an aspect of great importance in paintings. In this approach, as an object is painted, breaks are allowed to occur in the contours; after each interruption the line is continued until the overall shape is completed. The fascination of this approach lies in the fact that the eye will take in the whole form as if nothing were missing, challenging the viewer's perception.

Chinese Peonies is a good example of this technique. The shapes of the upper petals are lost in the bright sunlight, but their contours reappear in the shadow of the darker background. Even though their outlines are interrupted, we see the whole flowers because our mind searches for the missing contours to complete the familiar image of the blossoms.

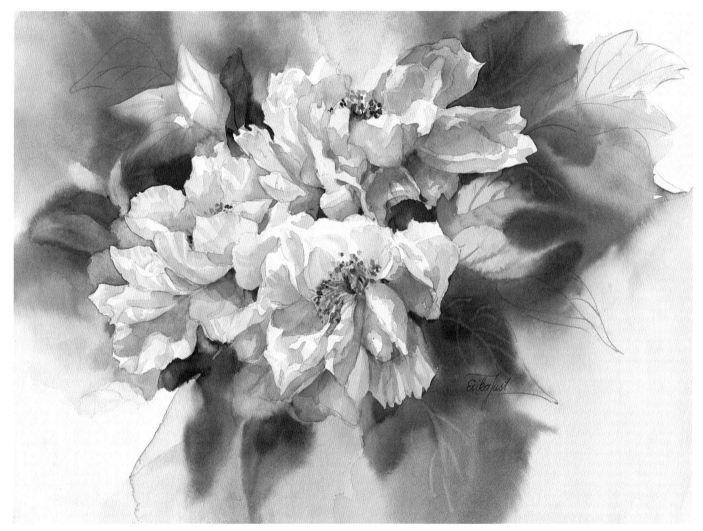

CHINESE PEONIES
13" × 19" (34 × 47 cm).
Collection of Mrs. Mary Ann Moss.

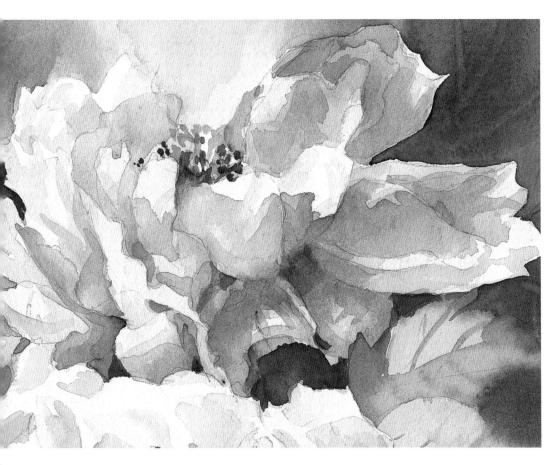

CHINESE PEONIES, DETAIL

The "lost-and-found" edges of the blossom in this sketch give the picture depth and make it more interesting; the viewer is challenged to interpret what is not quite obvious.

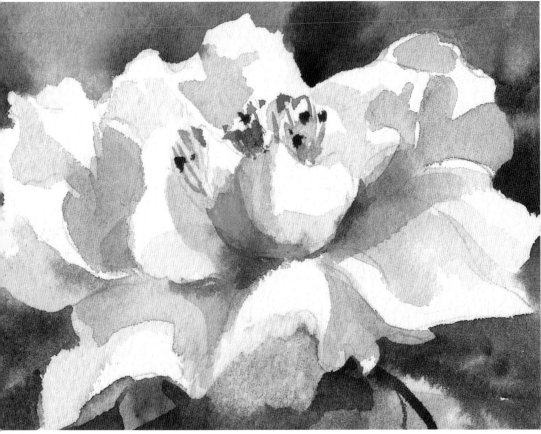

CHINESE PEONIES, SKETCH

This sketch shows the uninterrupted contour of the flower. The outline of the blossom is clearly visible around its entire circumference, leaving nothing to spark the viewer's curiosity.

Hard Edges

Hard edges are needed to differentiate between objects and give the painting a fresh, crisp look. Using them is an effective way to emphasize the main subject in the picture, especially if strong darks and lights are divided by crisp, hard lines.

When painting *Pink Magnolias*, I first put a wet-in-wet wash into the background and let it partially run into the area of the main subject. After the paper had dried out completely, I started painting the flowers. Every touch with a loaded brush on the dry paper produced a hard edge, clearly delineating the main subject. To soften parts of it, I immediately applied clear water to the untouched sides and let the color ooze into the water puddle.

A variety of soft and hard edges adds interest to a painting and brings it to life. The rougher the paper, the crisper the hard edge: if a loaded brush is moved quickly over dry paper, paint will touch only the tops of the paper surface. The brush should not be saturated; it should be wet enough only to leave the desired mark. This is best done with a flat or large round brush.

To produce irregular lines, the belly of a round brush is dragged over the paper. The amount of pressure applied will determine how full, light, or dark the tone of the brushstroke will be and how much pigment will be allowed to run into the little indentations on the surface of the paper.

Quick brushstrokes.

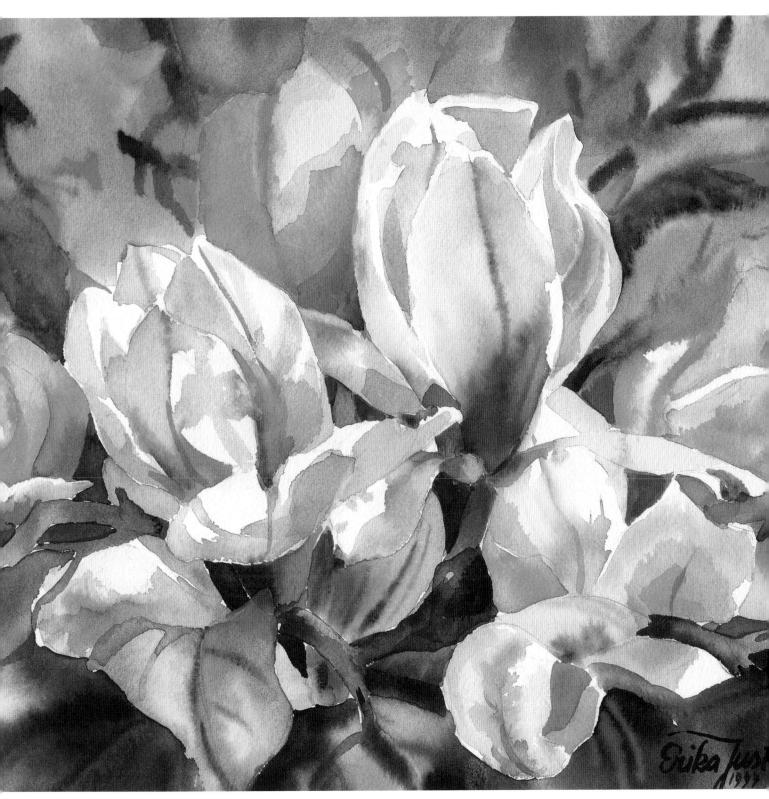

PINK MAGNOLIAS
10" × 11" (25 × 28 cm).

Creating Fuzzy Lines

Fuzzy lines make grass, branches, and delicate shrubs appear more interesting, but the technique for producing them requires some practice. Imagine the frustration of spoiling a freshly painted beautiful bouquet of flowers because the fuzzy lines depicting some decorative grass or shrubs ran haywire all over the background rather than remaining fuzzy. That will happen if there is too much water on the paper.

It is fun to practice this technique without the risk of spoiling anything by brushing strong colors onto a thoroughly wetted large sheet of paper. Just before the water shine disappears, tip a rigger # 4 into clear water, shake the excess amount of water gently off the brush, and draw only a single line into the colors on the damp paper. Miraculously, the remaining water from the brushstroke will push the paint aside by about a quarter of an inch or less, depending on the size of the brush and the amount of water applied. Now, with a little bit of luck, there is your fuzzy line!

You can draw all sorts of shapes on the paper, as long as it is still damp enough. The only criterion is the time factor. Once the paper is too dry, nothing will happen and you will just produce a wet line.

I enjoy watching the interactions taking place on my watercolor paintings. Once these techniques become second nature, good paintings will be your reward.

Fuzzy lines done with a rigger # 4.

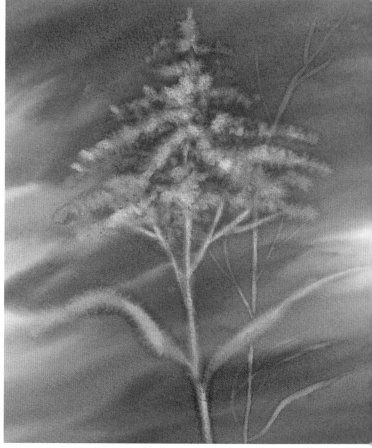

Fuzzy lines done with a larger round brush.

Using Salt

A good painting should always be surprising and exciting to look at, encouraging the eye to roam around the various shapes and forms, wandering from one detail to the next and discovering a diversity of interesting effects. Using salt can sometimes make the difference between a flat, rather boring wash and an exciting image. Using salt to get a few raspberry-like shapes at random is quite easy, but may not necessarily be what the picture needs. To produce special shapes, an interesting background, or a spray of flowers in a planned arrangement is somewhat more difficult and requires practice.

Using good watercolor paper is essential even for learning purposes, since each kind will react differently to the water, the paint, and especially the salt. For the salt to be able to pick up the pigment, the paint should be of a non-dyeing type like cobalt blue, French ultramarine blue, burnt sienna, etc.

To discover how salt reacts on paper in different stages of wetness, it is best to paint a good even background wash, and add at first just a few grains of salt. As the paper starts to lose its wetness, some more salt should be sprinkled on in various amounts, forming diverse shapes in different places. The last few grains can be added when the glistening on the surface is nearly gone. Once the paper is completely dry and the salt is brushed off, it is astounding to see the various results, depending on the wetness of the paper at the time the salt had been applied and on the amount of it used. On very wet paper big spots are created, while in areas where the paper was dryer, beautiful little stars appear.

To produce a cluster of flowers like lilac or goldenrod, sprinkle salt onto the paper according to the desired shape. When the paper is bone dry, brush the salt off. Once you have practiced this procedure to your satisfaction, follow the same steps again, then, after applying the salt, take a small brush and very carefully add some paint close by. In this manner you can enhance some colors and give the painting more variety.

Remember, the wetter the paper, the larger and hazier the spots become. Now, instead of putting salt on the paper, try to dip your fingers in water and sprinkle it onto the wash. The spots will be much larger and less defined.

This sketch clearly demonstrates how differently salt reacts if applied at various stages of wetness.

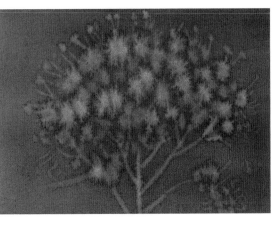

If using permanent dye, the salt grains will not take out all the pigment. As a result, the contrast between light and dark will be muted.

Distributing the salt grains evenly and sparingly on the paper when the shine has begun to disappear will produce little stars in the sky or a whirl of snowflakes.

PINK CATTLEYA, DETAIL

Salt will be able to absorb a larger portion of the pigment if non-dyeing colors such as French ultramarine blue, cobalt blue, or burnt sienna are used. They do not dye the paper permanently because the pigment is large and remains on the surface. The little stars or spots will become lighter, in better contrast to the darker wash. Learning to control these techniques will enable you to create additional effects in your watercolor paintings.

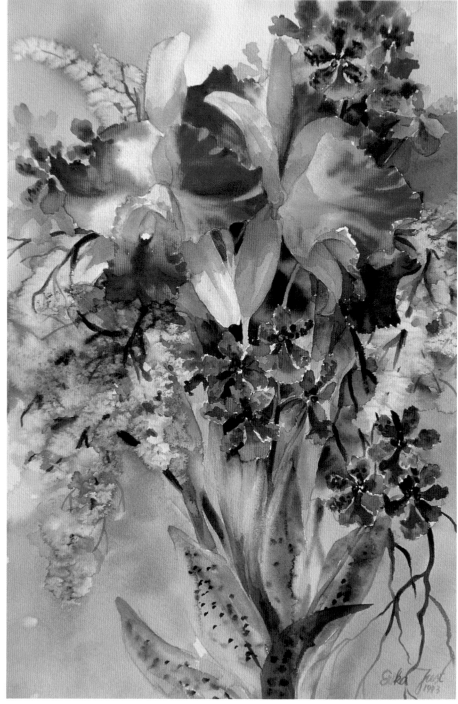

PINK CATTLEYA
21" × 15" (54 × 37 cm).

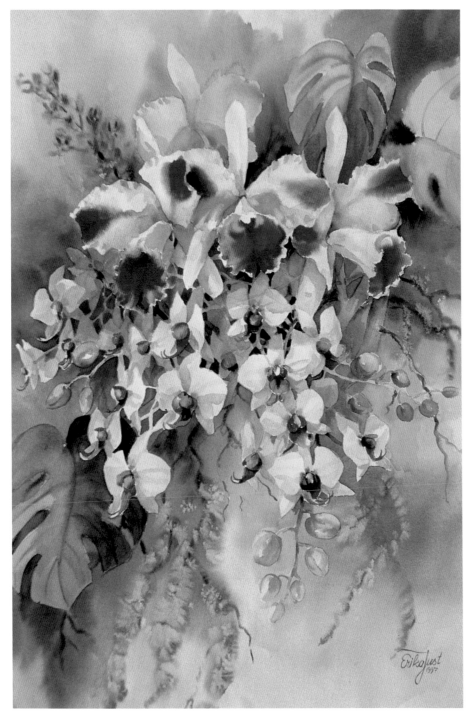

CATTLEYAS AND PHALAENOPSIS
30" × 22" (76 × 56 cm).

**CATTLEYAS AND PHALAENOPSIS,
DETAIL**

*In this painting, I used coarse and
fine salt at various stages during the
drying process of the paper. I dropped
the coarse salt grains on the damp
paper to develop the beautiful blossom-
like shapes. Using the fine salt very
sparingly once the paper was almost
dry produced lovely little stars.*

How to Use Masking Fluid

Masking fluid is a wonderful invention. In the early days, wax or masking tape were the only means to cover up areas that were to remain untouched by paint. Masking fluid is latex based and can be painted over as soon as it is completely dry. It is very easy to remove, for example, with a rubber eraser. Once removed, the forms and shapes to be painted into the areas that had been covered by masking fluid should blend harmoniously into the design without dominating it. I personally prefer the yellow to the white Winsor & Newton masking fluid. It is less viscous, more suitable for drawing fine lines, and better visible on white paper.

Before finding out how to apply masking fluid in a practical way, I ruined just about every brush I used in the process. The latex content of the fluid sticks to a dry brush and will not come off again, so if you don't pay attention, your brush will end up in the trashcan.

A wet, clean brush should be liberally soaped with a bar of soap before it is dipped into the masking fluid, which should be stirred gently rather than shaken as indicated on the label. To keep the fluid from clotting up, the bottle should not be left open.

Masking fluid, soap, and water.

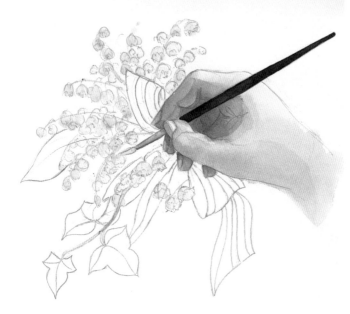

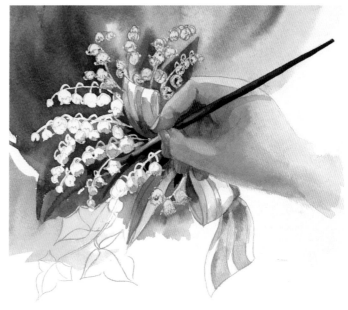

The little flowers in this sketch are covered with masking fluid. After dipping the brush into the masking fluid four or five times, it is advisable to rinse the brush thoroughly with fresh water and soap it again. Latex dries out very quickly in air. If it is not washed off the brush in time, it will adhere to the bristles and the brush will lose its sharp point.

It does not take more than a few minutes for the masking fluid to dry on the paper, so that the background can be laid in. Once everything else is finished and properly dry, the masking fluid can be removed, using a rubber eraser. Now all the flowers and other details can be painted in without any problems.

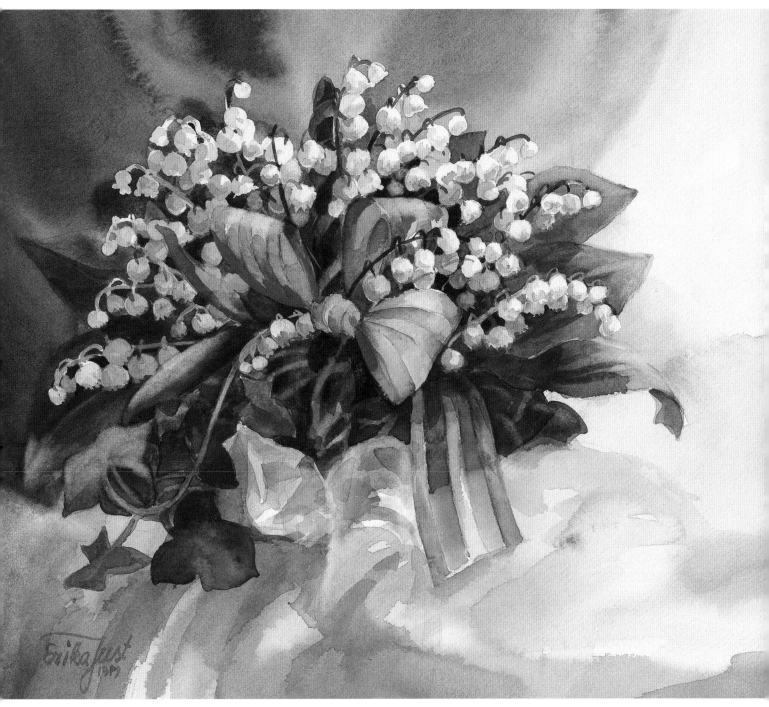

LILIES OF THE VALLEY
11 1/2" × 13" (29 × 33 cm).

Working with a Brush Handle

To draw dark veins or ribs into a leaf or flower, the back of a brush handle or some other pointed tool can be used to trace lines into the wet paper. Paint will run into the little grooves and darken them.

To draw grass, veins, ribs, or unusual leaves that are lighter in color than the surrounding hues, paint must be removed.

Just press down and scrape.

While most of the pigment is still on top of the surface and the paper is still damp, the handle of a Winsor & Newton series 995 flat brush can be drawn firmly over a dark surface. The pigment is pushed aside and lighter shapes remain. When it is done right, the result can be very satisfying, as is shown in the following example.

Once you have seen a field of "Sensations," the name of the flower becomes instantly understandable. Large blooms in colors ranging from white to pink and magenta red sway in the breeze on their yard-long, delicate stems like little ballerinas. Painting the blooms is not a problem, but to paint the fine, pine needle–shaped leaves most certainly is. Painting each leaf separately would create a very tight impression, which I like to avoid; therefore I used the brush handle technique.

PINK SENSATIONS, DETAILS

Approaching the problem with the brush handle technique, I had to work fast, putting down a heavy mixture of sap green, French ultramarine blue, sepia, and magenta. Magenta was necessary for the underlying blossoms, and I hoped that the pigments would follow my bidding and let themselves be scraped out properly. I also expected the sap green paint to dye the paper faster and remain when the pigments of the other colors were removed. At the appropriate time I scraped the leaves out of the damp paper, and voilà!, it worked like a charm.

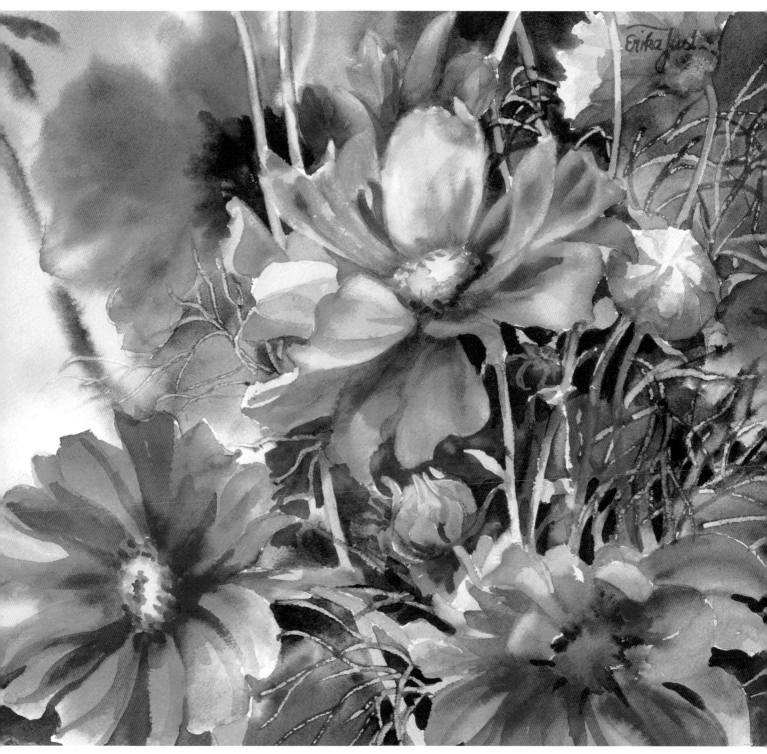

PINK SENSATIONS
10" × 11 1/2" (25 × 29 cm).

Stencils

Stencils are tools used to create lighter or darker shapes in previously painted areas by adding or removing pigment. Cutting a shape out of a piece of heavier watercolor paper or adhesive paper produces two stencils, a positive one in the desired shape, and a negative one with a hole in the same shape. Both stencils can be used to produce positive or negative shapes. Painting dark color over the stencil with the hole in it would, for example, produce a darker leaf on a lighter background, while rubbing pigment out of that hole would produce a lighter leaf on a darker background. Alternatively, using the positive part of the cutout shape, paint can be rubbed out, painted in, or glazed around the stencil without altering the pigment underneath it. Rubbing out paint produces soft edges, whereas painting over stencils produces hard edges. Areas can overlap, and the procedure can be repeated as often as required. If the desired shapes are simple, masking tape can also be used.

ABOVE: *Stencil and its counterpart.*

LILIES OF THE FIELD
20" × 21 ¹/₂" (50 × 55 cm).
Private collection.

As if illuminated by a spotlight, this cluster of lilies shows striking contrasts between the bright blooms and dark background. Where the sun touches the outside of the blooms, their purplish color changes into a bright white glow, right next to the dark colors of the shaded flowers and deep darks in the background. Painting such riches of nature is most rewarding!

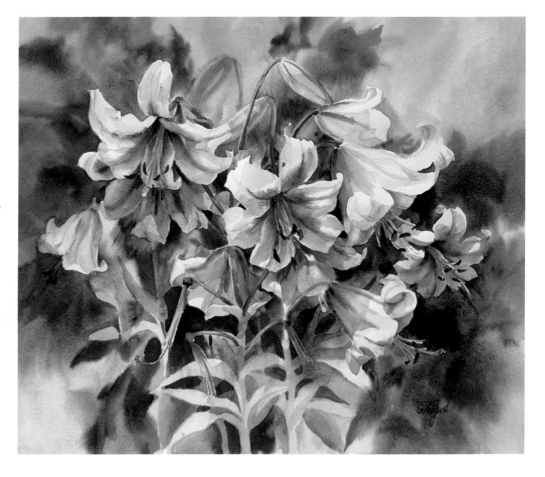

The Translucency of Petals

The thickness of petals varies greatly among flowers. Magnolia blossoms have very thick petals with a velvety feeling to the touch and are quite opaque. On the other hand, the petals of daffodils are translucent and shiny like Chinese silk, and where they overlap, underlying petals will shine through at their points of contact. The color of green leaves under translucent petals will shine through in the same hue but with a much lighter value.

If the flower arrangement is backlit—a wonderful way to present it and draw the viewer's attention to the point of interest—two overlapping petals appear in strong contrast to each other. The part of the upper petal in direct light is nearly colorless whereas the part shaded by the underlying petal is dark and appears in intensive hues.

There is a simple way to achieve this effect in a painting. Two flowers are drawn, one over the other. The upper blossom is painted in a light value with some parts untouched by color to indicate bright light. The lower blossom is done in a darker value, the structure and folds of the petals are painted in, and after everything is dry a touch of the underlying color is glazed over the area where the upper and the lower petal cover each other. The shape of the lower one will then appear to shine through. This effect is shown in *A Touch of Spring*.

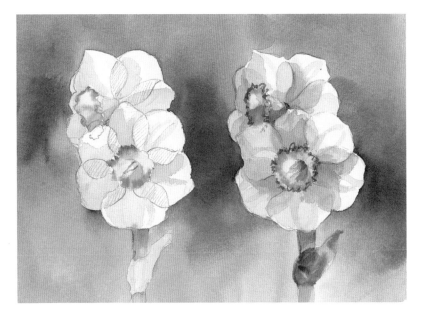

ABOVE: *Transparent petals.*

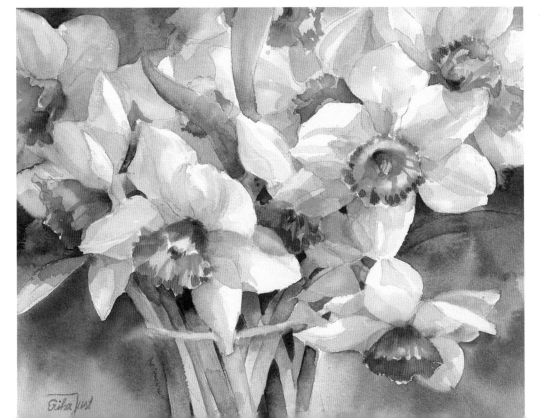

A TOUCH OF SPRING
11" × 14" (28 × 34 cm).

One white petal of the blossom on the right-hand side overlaps the orange center part of the under-lying flower. After rewetting this small area, I gave it a light touch of orange, so that the white petal appears to be translucent.

53

Glazing Techniques

Glazing is a technique that was perfected by the old masters, using oil as their medium. Thin layers of transparent pigment were laid on top of each other to create colors of incredible luminosity and richness. In water-color painting the expression "glazing" is also used, but is somewhat misleading because the technique is the normal way of working with this medium. Only after the paper is totally dry can the next shape be painted over the previously laid-down color, which will then shine through. The white surface of the paper will enhance the luminosity of the paint, giving it the appearance of being lit from within.

Colors with very fine ground pigment like Prussian blue, sap green, Antwerp blue and green, peacock blue, and a few others are very transparent and work best. A few layers of paint can be built up that way, but based on my experience too many layers will blot out the whiteness of the paper, and the luminosity of the colors will be lost. Opaque colors like ochre, Davy's gray, and cobalt green and blue cannot be used for glazing, because they are not transparent and therefore will cover the underlying paint rather than letting it shine through. A perfect example of glazing is the transparent tablecloth below.

● STEP 1
The first wash of transparent permanent dye is put down with a flat brush. For the next layer of paint the paper must be very dry, unless you want back runs to occur.

● STEP 2 (LEFT)
The next layer of transparent color is put onto the first wash with dry brush strokes.

● STEP 3 (ABOVE)
Once the paper is completely dry again, the third glaze can be applied, working on the pattern of the lace to bring it out beautifully. The glazing can be repeated as often as necessary, keeping in mind that with each additional layer the color is getting darker. The more glazes applied, the less transparency will remain.

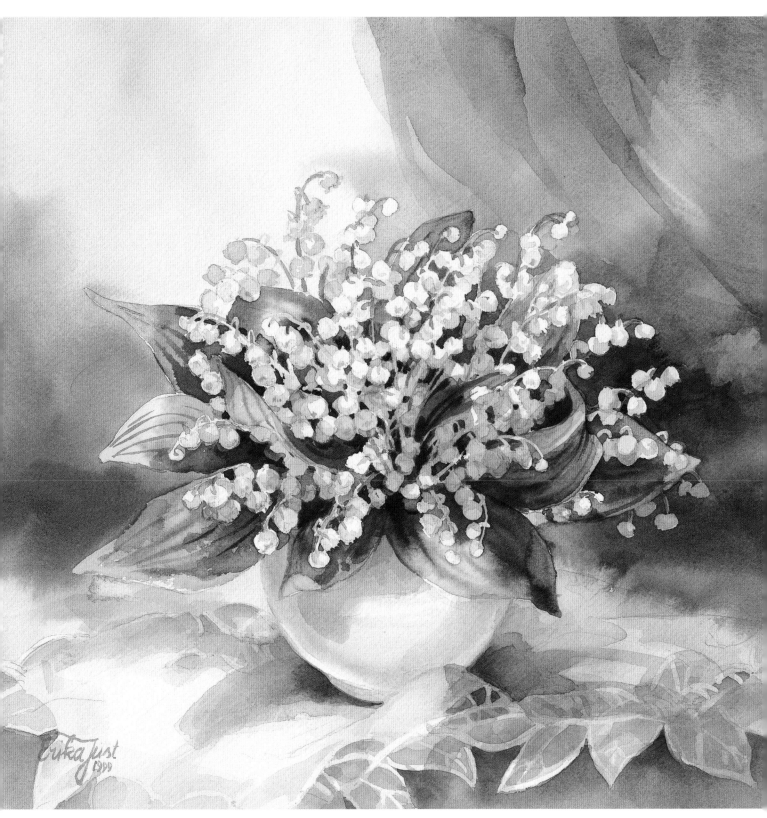

LILIES OF THE VALLEY IN A ROUND VASE
10$^1$/$_2$" × 11" (27 × 28 cm).

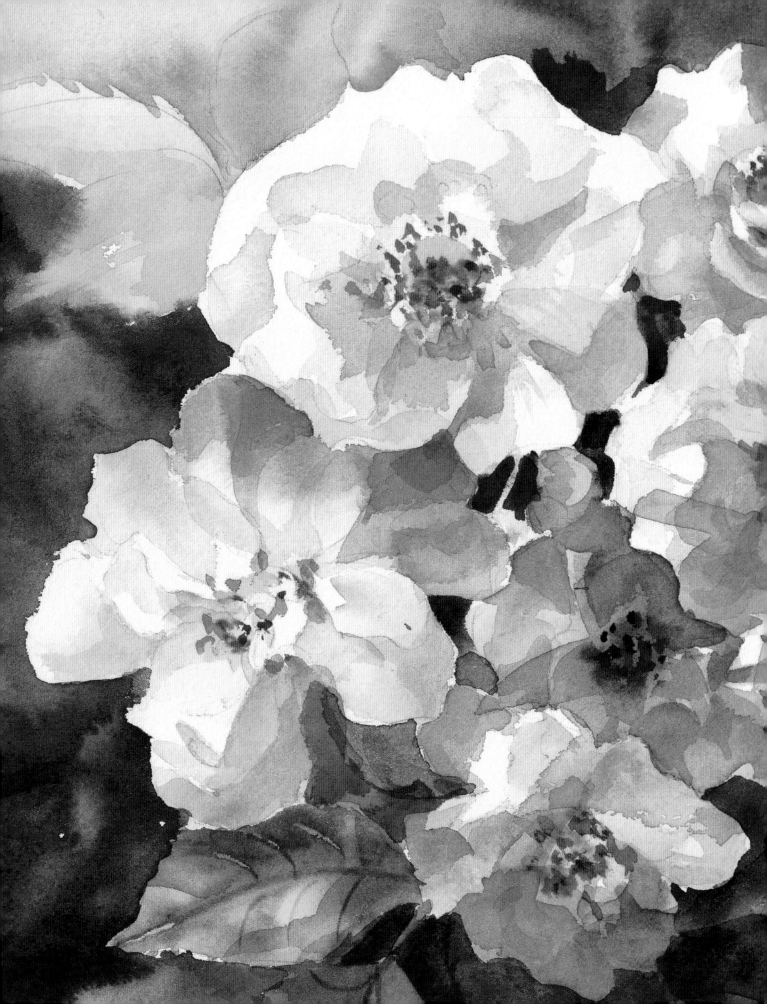

How to Approach
a Painting

Knowing Your Subject

Returning to nature again and again as the great source of truth for inspiration and guidance is a must. Selecting themes, planning pictures, and sketching objects is most rewarding. Drawing from nature improves the ability to observe and understand why things look the way they do. That is not to say that everything should be painted exactly as it appears to the eye. Only the essentials are important; going into great detail would leave nothing to the imagination.

Every little flower, tiny leaf, dead tree trunk, or rock offers magnificent design ideas. These should be studied, analyzed, and used. To become aware of these hidden little treasures, which escape the attention of most people

who fail to look, and learn to see them makes all the difference. Consider your brain as a computer that must be programmed. Since you can paint well only what you recognize and understand, it is absolutely essential to know why things look as they do and file that knowledge in your permanent memory.

Take, for example, a tree. To a person who has never shown any interest in trees, all of them may simply look tall and identical, which is quite an injustice to these magnificent plants. Trees differ widely in color, shape, and size. Leaf colors in early spring appear in soft yellowish green; in summer the strong dark hues dominate, while fall surprises us with a fairy tale

DAISIES AND FRIENDS
10¹/₂" × 14¹/₂"
(27 × 37 cm).

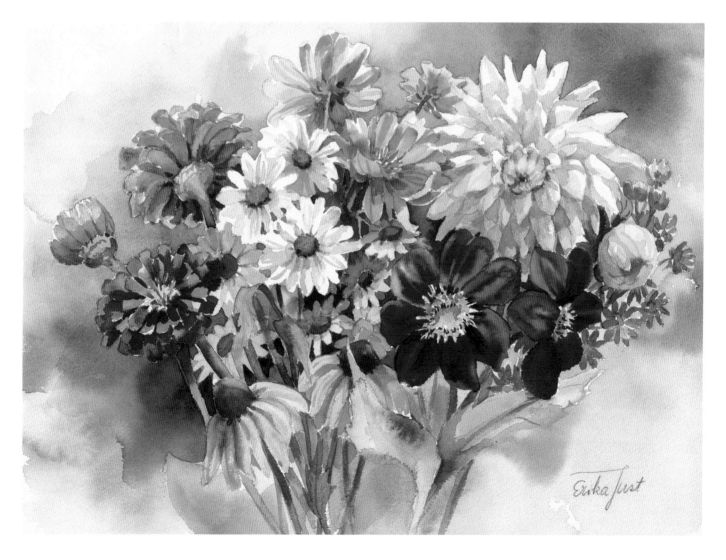

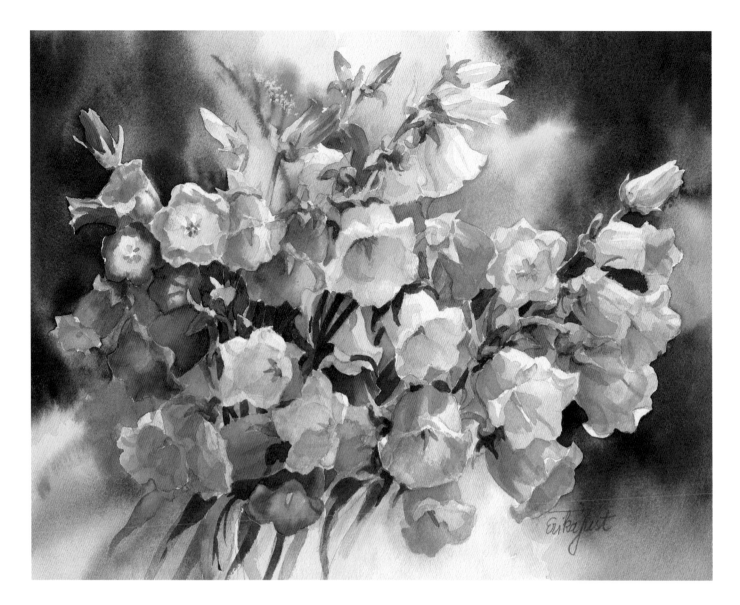

of multiple reds, yellows, and browns, ending in winter with the soft grays of the naked branches.

The same is true for flowers. I always have to laugh a little when I hear people say, "I cannot paint flowers!" Does this mean they cannot paint daisies, bluebells, or roses, or does it mean that they cannot recognize the shapes of these flowers? The latter would be understandable, since the diversity of flowers is so much greater than that of leaves or trees.

The simplest flower is probably the daisy, having a circular shape with oblong white petals around a yellow center. Many other flowers grow the same way, like crown daisies, Black-eyed Susans, corn marigolds, golden feathers, China oysters, etc. Nature must have liked the design so much, that it went ahead and created asters, dahlias, chrysanthemums, zinnias, peonies, etc.—all daisy-like, but filled with many more petals, in different shapes.

Then there are flowers that resemble little bells and trumpets, like bellflowers, Canterbury bells, delphiniums, and others. They are a challenge to paint. Compared with the flatter shape of daisies, the depth of bell-shaped flowers requires a good understanding of their structures and of the interaction of light and shadow in the depth of the blossoms.

The shapes of pansies are quite charming. With their four overlapping petals on top and one large petal across the bottom, they seem to have little "faces." Pansies exist in all colors (see *Pansies and Daisies* on pages 2–3 and *Bouquet with Blue Ribbon* on page 5).

CANTERBURY BELLS
10 1/2" × 14 1/2"
(27 × 37 cm).

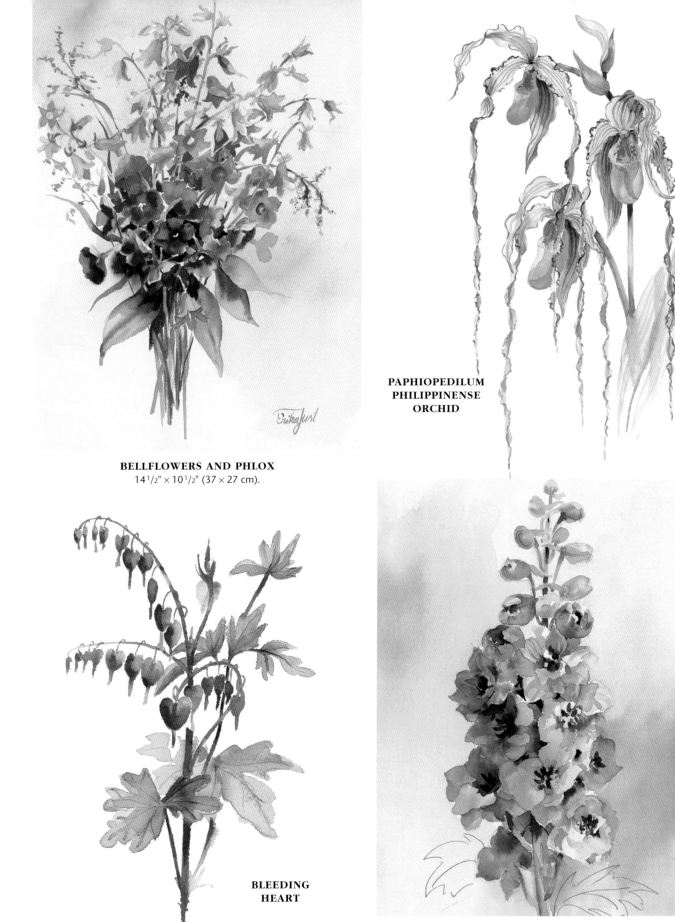

PAPHIOPEDILUM PHILIPPINENSE ORCHID

BELLFLOWERS AND PHLOX
$14^1/_2" \times 10^1/_2"$ (37 × 27 cm).

BLEEDING HEART

DELPHINIUM "BLUE BEAUTY"

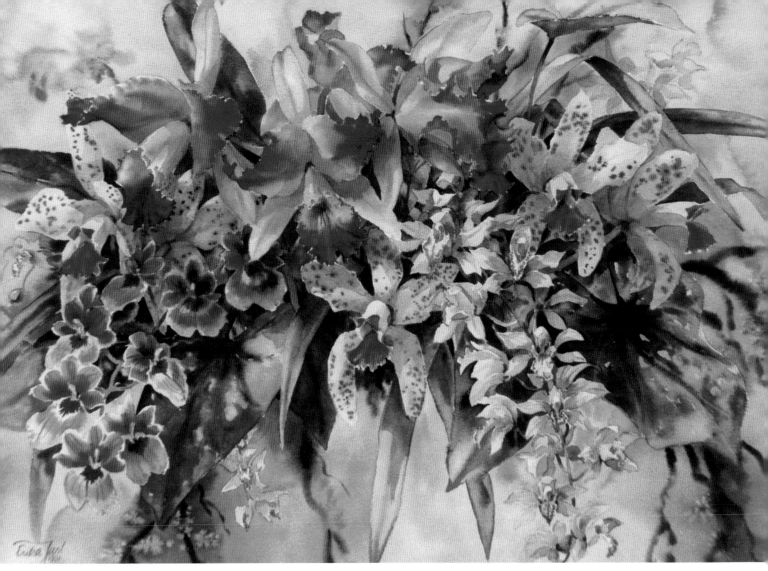

Orchids in their multitude of shapes.

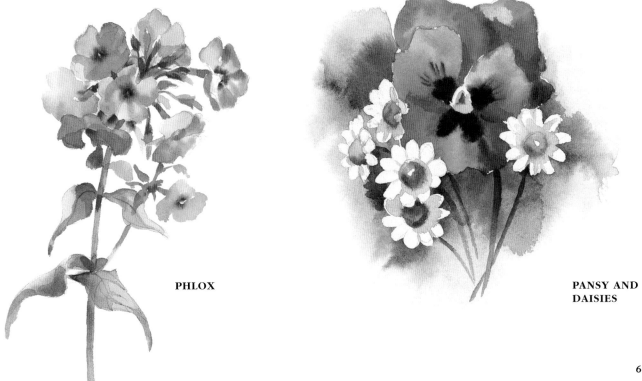

PHLOX

**PANSY AND
DAISIES**

Leaves

Leaves should be carefully studied to differentiate and distinguish their beautiful colors and shapes. They should never be depicted as simply green, which would make them look like the proverbial spinach. Although most of them are not as colorful, painting leaves is as interesting as painting flowers. Some of my students were of the opinion that leaves are just "green" and "boring" to paint. What a misconception! Although less striking than flowers, leaves may be quite colorful themselves, and surrounding hues may reflect on their shiny surface. In an arrangement of brightly colored flowers, cool colored leaves may bring calm into a bouquet; conversely, the painting may be livened up if the flowers are white and the leaves are of brilliant hues.

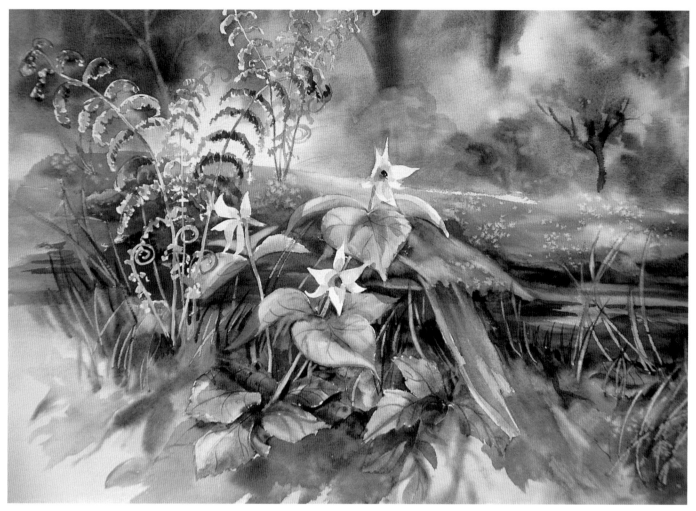

DECAY BEGETS LIFE
22" × 30" (56 × 76 cm).

This inconspicuous white trillium was growing right among the ferns beside the moss-covered trunk of a fallen tree. In the dark of the woods the little flower was radiating like a shining star. Different hues interrupt the monotony of green leaves.

● ROSE LEAVES

Young rose leaves are warmly colored when they first unfold. They vary from a deep magenta to brown madder. As they grow, they turn green and eventually yellow and brown. If they develop spots and get gnawed at by bugs, it is to the gardener's sorrow and the artist's delight. There is no pigment on the palette that cannot be used to show their beauty. I let the colors mingle on the wet sheet and use the brush handle to scrape the veins into the paint while it is still wet, so that some of the pigment may drain into the little grooves.

● LARGE BLADES OF GRASS

This sketch is a play between light and dark colors. A fast brushstroke over rough paper creates a glittering shine. I touched the tips of the blades with burnt sienna; for the dark parts in the shadows I used French ultramarine blue to give them variety and differentiate them. Remember, "spinach" is out!

● IVY

Even the small inconspicuous ivy shows pink hues on its stem and new leaves. After the yellow wash for the leaves was dry, I glazed it with green, letting the veins remain untouched as little yellow lines. That gave it a fresh and crisp look.

● GROUND COVER

Some ground covers resemble flowers more than leaves, sporting bright red edges. These brilliant colors can be simply reproduced with opera and permanent red. The leaves are fun to paint using the glazing technique. I painted the little plant with aureolin yellow, sap green, and cerulean blue, using a yellowish-green under-paint. Its veins were done partially with the brush handle by scraping out some of the color and partially by glazing a darker green over the yellow ground color. Little red tips indicate new growth.

● PUSSY WILLOW

I painted this pussy willow with a large amount of dark paint at one spot and scraped some blades of grass out of it with the brush handle, moving from the bottom to the top. I then painted the light colored grass and stems. The heads I did with burnt sienna, and by applying a touch of water I allowed a little color to leak out where the seeds explode.

● FERN

Ferns are beautiful to look at in their various stages of growth. In late spring the shoots come out of the ground in the shape of little green balls, nestled into last year's dried-out twigs. They then start to unroll and unfurl their ancient beauty.

Starting a Painting

Some of my students are reluctant to place the first dab of paint onto the untouched, white sheet of watercolor paper in front of them. The paper seems to say: "Don't touch me; don't mess me up!" To overcome this uneasiness, I've found it helpful to begin with a preliminary soft wash, which allows shapes and images to appear more or less at random. Some areas of course should be left clear, so that an appropriate lighting situation can be developed later.

Occasionally on a slow day, especially in dreary weather with low clouds hanging over the landscape, it happens that I want to paint, but nothing comes to mind. As soon as these wonderful soft colors of the first wash start blending, my imagination begins to work. All sorts of shapes appear—leaves and flowers, daisies, forget-me-nots, roses, irises, etc. Once the basic colors of the painting are established and the paper is completely dry— that is, to a crisp touch—I design the main subject, drawing over the preliminary wash. Starting to paint, I sometimes enhance the underlying color, or ignore and overlay it, and the work begins to flow.

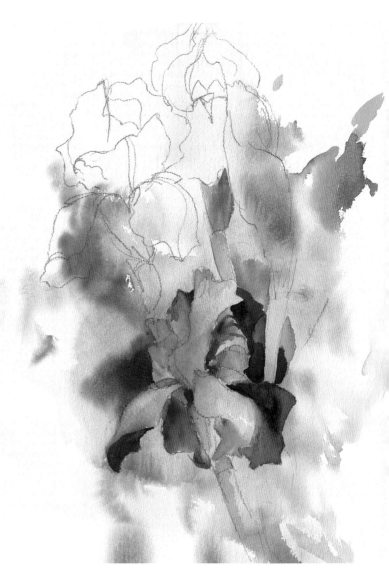

ABOVE: *An example of a preliminary wash.*
RIGHT: *In this particular case, I glazed over the under-paint, partially ignoring its different hues.*
OPPOSITE TOP: *After first sketching these irises, a few brushstrokes provide just enough color to gray down the paper.*
OPPOSITE BOTTOM: *Now it is easy to finish the painting.*

In cases where the subject is clear in your mind, it might work better to make the drawing first and dip the brush into a mix of very light colors for a preliminary random wash afterward. This helps a hesitant painter overcome the reluctance of touching a pure white sheet of paper with strong colors right away. *White Gladiolas* (see page 113) and *Irises* (see page 119) were done in this manner.

Some people like to dig into a new painting right away without doing any sketches beforehand. I liked to do that myself, but have learned since then that drawing sketches is fun, and working out problems before starting to paint considerably enhances your ability to produce a good painting.

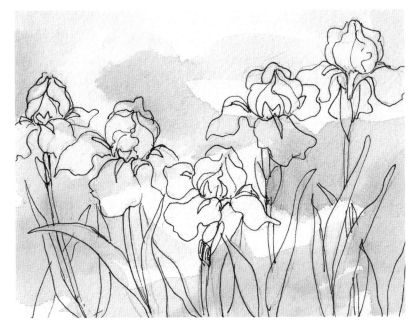

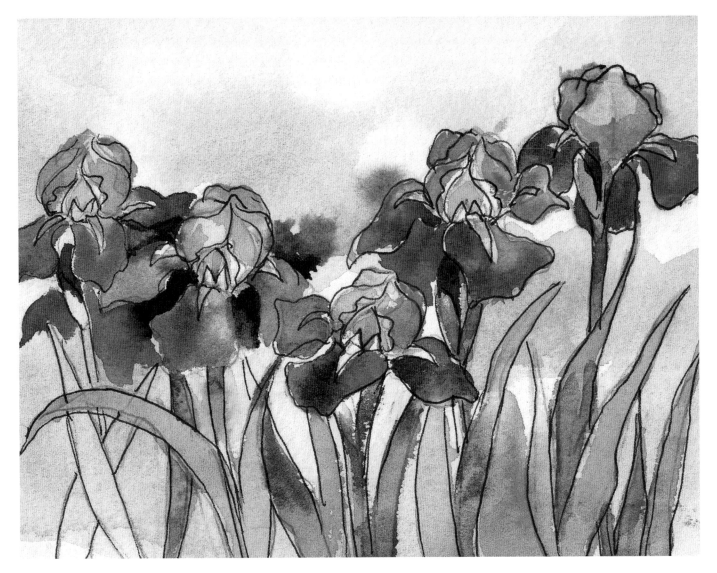

If you cannot make up your mind how to approach a theme, it can be very helpful to make a number of simple little sketches and to try out various sizes and formats. It is not necessary to go into detail—the idea is to develop the most attractive layout and determine where the light should come from and how intense the lights and darks should be. Most potential problems can be prevented that way. Going for a walk, I usually make quick pencil or color sketches of things that interest me; that way, I remember the colors, and the sketches may come in handy at some later time or be used as a reference. I draw and paint various plants from different sides and try to memorize their forms and shapes, allowing me after many years of practice to draw and paint most flowers in various situations from memory.

To do color sketches outdoors, a very small palette with just a few colors is quite sufficient. In addition to my sketchbook, I usually take with me a small container of water, a folding chair, and that other most-valuable implement, a roll of paper towels.

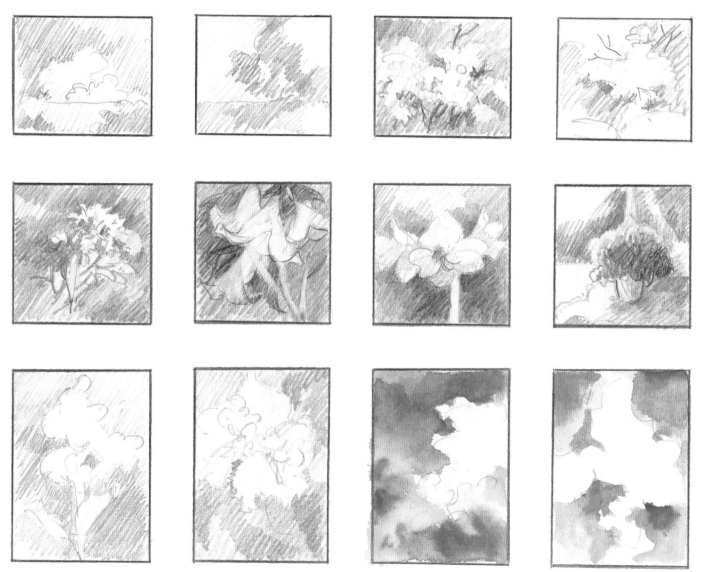

Pencil and color thumbnail sketches.

WORKING OUTDOORS
11" × 15" (28 × 38 cm).

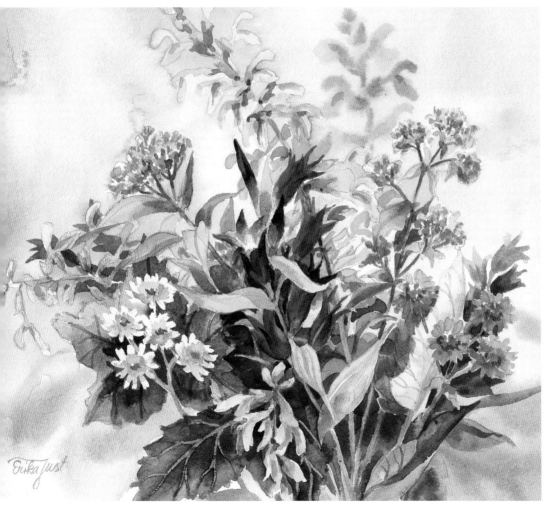

FLOWERS OF THE FOREST
11" × 12" (28 × 31 cm).

I put together this bouquet of flowers by selecting various color sketches from my sketchbook, in the comfort of my studio. To give the picture depth, I painted the flower in the far background first, using the wet-in-wet technique, and the flowers in the bouquet after the paper was dry. Using the brush handle technique for the veins in the leaves, I scratched little grooves into the wet paint for the darker veins and scraped color off the damp paper for the lighter ones. The approach to a painting depends on the subject and the individuality of the artist, but most important of all, the work should be a pleasure, as was the case especially with this piece.

Working from Photographs

I seldom leave home without my camera, not wanting to miss any opportunity to photograph an unexpected beauty for reference at some later time. I live at the foot of the Höllengebirge Mountains (Hell-Mountains) at the shore of a lake. In wintertime it becomes difficult to obtain certain flowers I would like to have when planning a new painting. On such occasions, I consult my photo album and always find something that stimulates my imagination. Using the photographs as a reference only, I never copy any of them but lay them out in front of me and organize the painting in my mind, using various parts and sections of each picture. Selecting a flower from one, a leaf from another, I make a few thumbnail sketches before working out the final design directly on the paper, and only then do I start to paint.

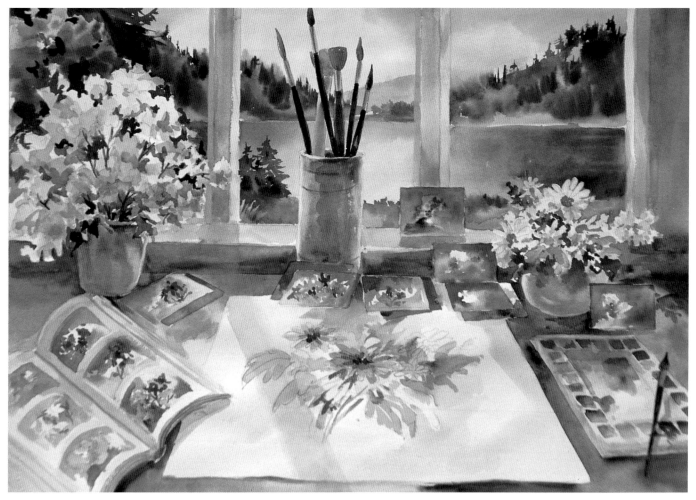

MY STUDIO
22" × 30" (56 × 76 cm).

Dramatic Value Limitations

Caravaggio is known as the inventor of "chiaroscuro" painting. Portraits by Rembrandt are legendary examples of this technique. Illuminated, radiating faces surrounded by white lace in front of dark backgrounds, or luminous hands resting calmly in the laps of darkly dressed people are the most dramatic means to bringing out the main subject. John Singer Sargent, Gustav Klimt, and many of their contemporaries occasionally used a contrary approach. In Sargent's portrait of Elizabeth Farren, she stands in an almost pure white dress in front of a light background, her dark hair providing the only accent. The dramatic staging of the contrasting approaches is unsurpassed.

Changing moods can be expressed in a painting by using dark, light, and middle value limitations. In a traditional value range, the larger part of the painting consists of middle-light to middle-dark values. Brighter lights and stronger darks are added to bring out the subject or set important accents. For most painters this is the "normal" way of painting. However, as a creative artist you have the ability and the tools to direct the play and to dim the painting, lighten it, or spotlight it. Once you are ready to create works of art and to experiment with variations on a theme, try different value limitations.

These sketches demonstrate how the same subject can be painted using different value limitations. Each sketch expresses a different mood.

● LOW KEY PAINTING
Most of this sketch is rendered in middle-dark and dark values, forcing the small lighted area into a powerful accent. Some of the light edges can be softened into the darks. Beautiful examples of low key paintings are *Hidden Treasures* (see page 33) and *White Lilies* (see page 70).

● HIGH KEY PAINTING
This high key sketch represents the other extreme. Most of its hues are much lighter than middle value. Sparkling transparent colors are glazed over each other with very light pigments. Only some of the flowers and their centers are darker than middle value.

● MIDDLE VALUE PAINTING (LEFT)
This kind of painting is very exciting, but quite difficult to do. Instead of bringing the subject out by setting light hues against dark ones, it is created by setting cool colors against warm colors, nearly all of them in middle value. Light pigments are limited; darks are used only for accents. In this sketch, I used complementary colors and some mixed neutrals to lessen the brightness of the paint. The subdued areas help to avoid garishness and give the sketch a rich look. *Pink Cattleya* (see page 46) illustrates the contrast between cool and warm colors very clearly.

WHITE LILIES
(LOW KEY PAINTING)
20" × 21 1/2" (50 × 55 cm).

These magnificent white blooms are set in front of a dark blue background in this low key painting. Compared with a normal value painting, more than two thirds of its hues are darker than middle tone. I used different blues and greens darker than middle value, and reinforced the darkness with French ultramarine blue, Prussian blue, and a small amount of sepia. The images of the delphiniums in the background behind the white blossoms were painted partially in negative and partially in positive shapes to inspire the feeling of depth. Painting around the subject instead of painting the subject itself creates negative space and positive shapes. Combining various positive and negative shapes entertains the viewer, whose eyes are guided through the painting from point to point, following your guideposts.

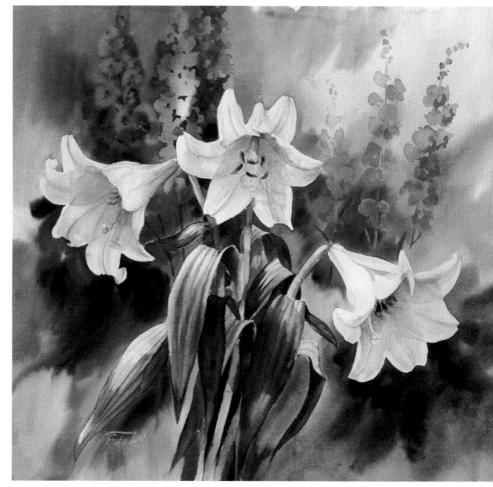

I DREAM OF SUMMER
(HIGH KEY PAINTING)
22" × 30" (56 × 76 cm).

In this high key painting, the majority of pigments are much lighter than middle value. Parts of the white daisies are left out of the light colored background wash. Sparkling transparent colors are glazed over each other with very light pigments. The colors are harmoniously placed, cool against warm and rich against neutral. Only some of the flowers and their centers are darker than middle value. The richest dark is kept to a minimum and is put in beside the white daisies to give the painting a strong structure and avoid a wishy-washy appearance.

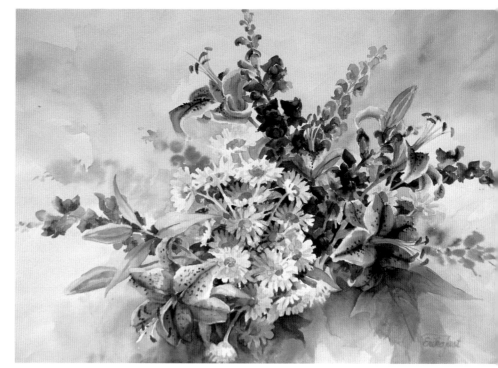

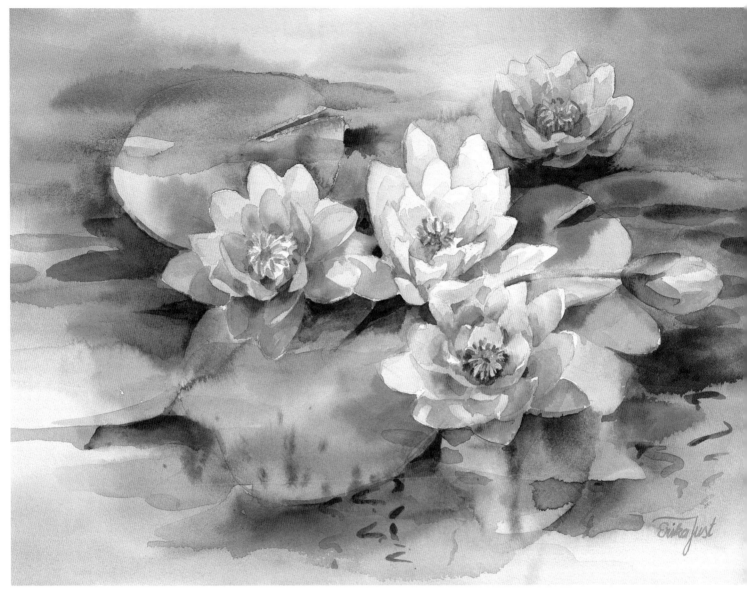

WATER LILY POND
(MIDDLE VALUE PAINTING)
17" × 22" (43 × 56 cm).

The subject in this middle value painting is not only brought out by contrasting light hues against dark ones, but is mainly created by setting cool colors against warm ones, most of them in a range of middle value. Light pigments are limited and darks used only for accents. Complementary colors and some mixed neutrals help to alleviate the brightness of too much pure pigment. The subdued areas help to avoid garishness and give the painting a rich look.

Your Point of Interest

It is fun to play with different possibilities in order to bring out your main subject. In *Spring Is Upon Us*, partial backlighting was used as a means to emphasize the setup. The little vase of spring flowers appears to be backlit. The colors of the flowers in the middle range or in the half-shadow are more intensified. The middle range shows strong and warm hues, whereas the color of the sunlit blooms appears to be washed out. Placing this whole arrangement in front of a darker and cooler background brings out the bouquet beautifully. It helps to work in extremes.

In *Lilies of the Field* (see page 52), the lilies appear to virtually jump out of the page, an effect achieved by placing the lightest lights and darkest darks side by side. The light shines from above and illuminates the individual blossoms and leaves to create the impression of fine lacework, leading the eye around the painting.

In *White Gladiolas* (see page 113), a light and luminous mass of white flowers in front of a very dark background is a most effective way to draw a viewer's attention to the point of interest. Strong contrasts between light objects and dark surroundings were often used by the old masters to emphasize their main subjects.

Still another possible way to accentuate your design is to set warm colors against cool ones as shown in *Nasturtium* (see pages 124-125). The blossoms are painted in very

SPRING IS UPON US
10 1/2" × 14 1/2"
(27 × 37 cm).

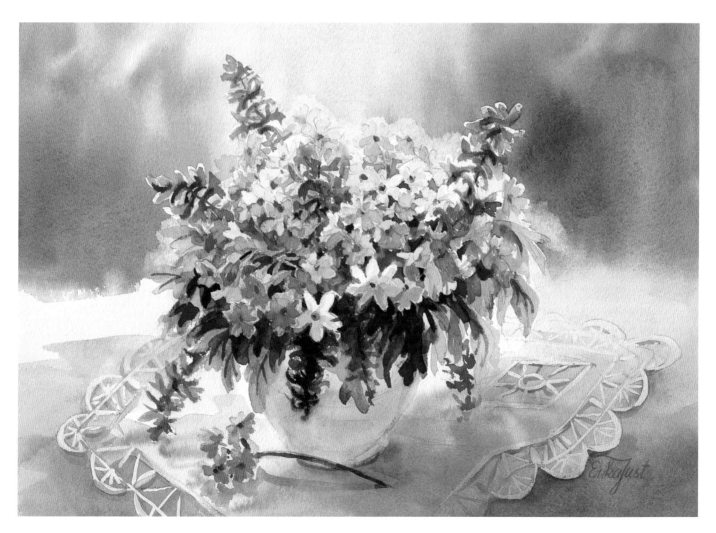

intensive hot hues, varying from yellow to red, enhanced by the cool colors of the blue-green leaves and blue-purple background.

An interesting effect can be achieved by choosing the middle ground as the main subject, allowing the foreground to become somewhat blurry. This setting may be visualized by looking into a meadow while lying in the grass, with the eyes focused on some flowers at a little further distance. To accomplish this, only the upper and lower parts of the paper are wetted; the middle portion remains dry. The fore- and back-grounds are painted wet-in-wet, with distant flowers in the background and soft hues in the foreground. Next, leaves and flowers are painted with crisp edges into the dry middle ground. They will seem to disappear into the wet foreground. Once the paper is dry, more plants are glazed over the first wash to illustrate the richness of the lush meadow. A few small dark accents are placed to bring out images of small flowers hidden in the grass and to give the painting a three-dimensional feeling. *Hide and Seek* illustrates how to emphasize the middle ground. I use this approach now and then because it is challenging and the outcome is always a surprise.

Look now at *Primary Colors*. What can be more dynamic than a painting done mainly in the primary colors—yellow, red, and blue? The different hues of blue that are used for the flowers and background are the predominant colors of this painting. The white daisies and garlic blossoms seem to be very important in spite of the intensity of the red and blue blooms painted directly beside them. What makes the white flowers virtually jump out of the page are the small dark red and blue gaps between the flowers and stems, repeating the colors of the blooms and giving the bouquet its three-dimensional harmonious appearance. Yellow is used in the background, for the centers of the blossoms, and to make up the green leaves. The background color was toned down in order to enhance the brilliance of the bouquet.

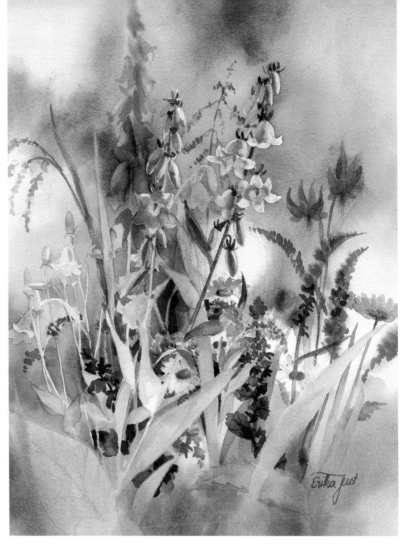

HIDE AND SEEK
15" × 11" (38 × 28 cm).

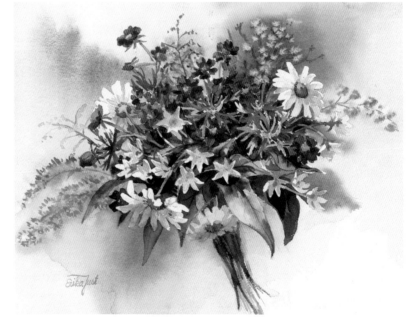

PRIMARY COLORS
10¹/₂" × 14¹/₂" (27 × 37 cm).

Checking Your Composition

There are several ways to create a near-perfect composition in a painting. Some artists do it by deliberation and following approved guidelines. Other painters follow their intuition and past experience, while still others use a combination of emotional intuition and adherence to proven recommendations.

I am a more emotional painter and believe that I have an inherent feeling for good compositions. Looking at one, I can discern whether it is well done or not, but certain guidelines are helpful for any artist. My father used to have endless discussions with his painter friends about design and composition. They speculated how in the old days a number of artists and critics might have sat together, maybe with a glass of wine in hand, trying to find out why some of the old masterpieces became famous while others were forgotten. They and my father probably began to realize that all the celebrated ones have certain things in common.

Many renowned works of art have a triangular structure in their basic design. The Madonna of the Meadow *(which can be seen in the Kunsthistorische Museum in Vienna) and* La Belle Jardinière, *both by Raphael, as well as* The Pietà *sculptured by Michelangelo are representative cases; their groups form triangles. In fact, whenever I contemplate a good painting, I see triangles all over the place. They appear to connect the various shapes and help to make the design more interesting.*

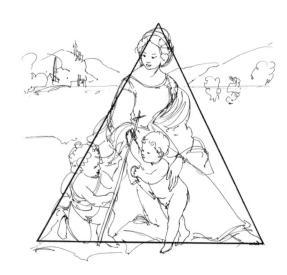

THE MADONNA OF THE MEADOW

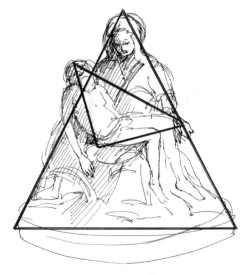

THE PIETÀ

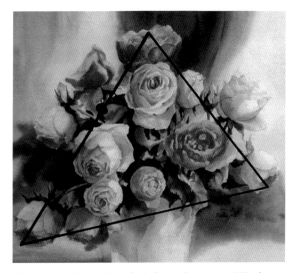

The composition of *Symbol of Love* (see page 79) also shows a design in the shape of a triangle.

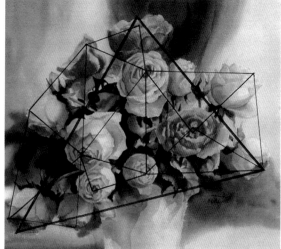

In this illustration a number of triangular configurations are shown within the painting.

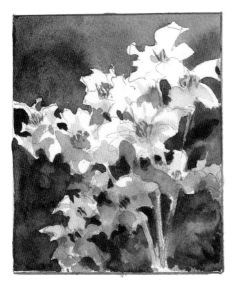

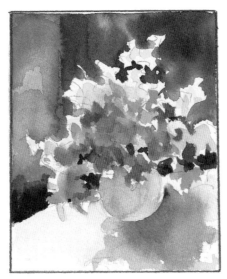

Other features common to the old masterpieces appear to be that the four corners of these paintings differ from each other, and that shapes, colors, and values vary along the four sides (left). The old masters either worked with dominating light, middle, or dark values or used dominating colors to create their famous compositions (far left).

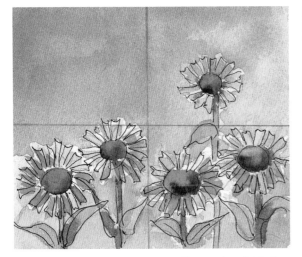

This sketch is very poorly designed! It can be divided into four separate units.

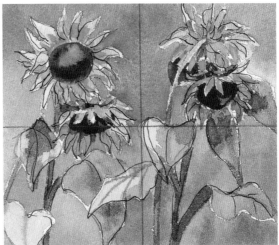

This is a better design, but the sketch can be divided into two vertical halves.

Another feature common to the old masterpieces is that their centers show nothing of great importance. The point of interest is deliberately shifted away from the middle. If the paintings were divided into four equal rectangles, the design would touch each rectangle differently, so that none could be viewed as a complete painting by itself. That way the composition leads the eye around the entire painting.

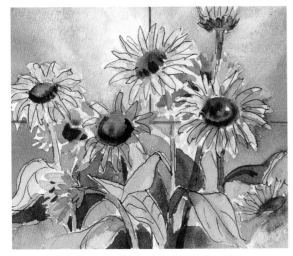

This design is a further improvement. The flowers are interconnected but the three colors are evenly divided and a dominating color is missing.

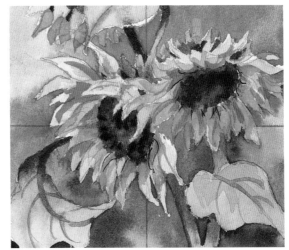

This design is very good! There is a dominating color. The blossoms are interconnected and point in different directions, forming two independent triangles.

Straight lines are hard wired into our brains. Being born in houses, we have been confronted from earliest childhood on with the straight and parallel lines of our baby beds, tables, walls, windows, etc. This is why the first things we notice in a painting are straight or parallel lines. Like magnets, they draw our eyes out of the painting before we are able to absorb its content. Therefore, straight, uninterrupted lines should be avoided. The simplest way to do this is to either curve or "loosen" them, as explained in "Lost-and-found Edges" (see page 40).

"Respect for the edge of the paper" may also be caused by our imprinted image of straight lines. For fear of having the composition going off the side of the page, there is a tendency to line up the blossoms neatly along the vertical or horizontal borders. This is a definite and absolute "no-no"! Painting the subjects oblique to each other and letting them go off the page in some areas can make the picture more interesting.

Symmetry, evenness, parallels, and even numbers are boring, especially if the depicted items are even in length and width. The great Ed Whitney used to lift two fingers and pronounce categorically: "Boring!" Then he would lift three fingers and say, "Interesting."

The most important words for a painter should be the words "too," "different," and "diverse." All paintings should be examined to determine the following: Is something too large, too small, too dark, too light, or too anything else? Does each object in the painting have a different size, height, edge, color, value, or shape? Is there diversity?

I prefer the term "suggestion" to the hard word "rules." Reviewing your paintings according to all these "suggestions" will help you to be your own best judge. I have pointed out some of the problems students may encounter in their endeavors and suggested how they can be solved. We should try to use all this acquired knowledge to our advantage to produce art of lasting value.

ORCHIDS FROM SINGAPORE
22" × 30"
(56 × 76 cm).
Collection of Mr. and Mrs. Taferner.

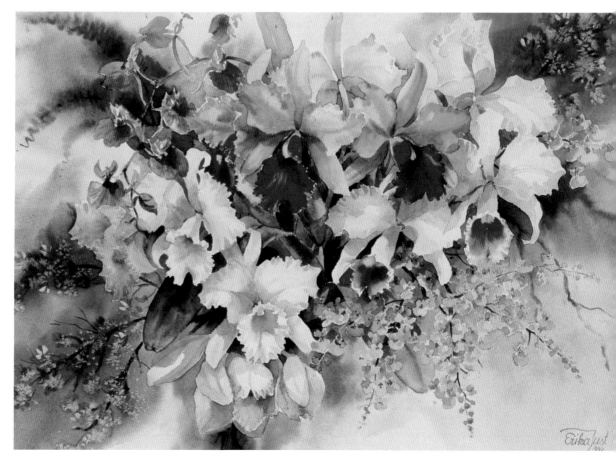

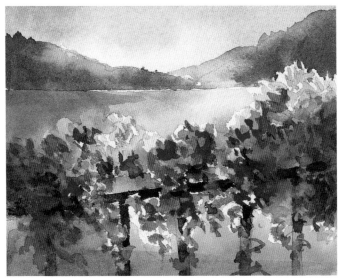

Straight, uninterrupted lines draw the eye out of the picture before the viewer can absorb the content.

In this sketch, the hanging flowers interrupt the straight lines of the banister. The design is much improved—the eye remains in the picture.

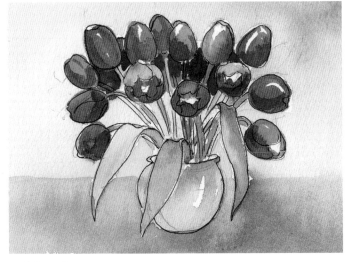

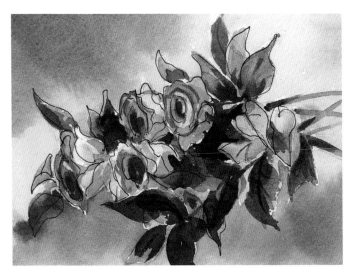

Bad design!

Interesting design!

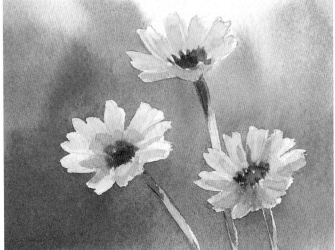

Boring!

Interesting!

When Is a Painting Finished?

One of the hardest decisions to make is to determine when my painting is finished. This is especially true if you enjoy painting as much as I do. Painting has never been work to me—it has always been pure joy. To say, "This is it," and put down the brush is always very difficult. I have found that when I look at my work and do not know what to do next, then my painting is "finished," at least for the time being. A few years, much experience, and many paintings later, looking at that picture again, I might have acquired new skills and better techniques and want to heighten its quality with new expertise. I might be able to add a few more darks or improve the balance between colors or the harmony in the design, but I could also end up wishing I had stopped earlier.

My recommendation is to listen to yourself and you will know.

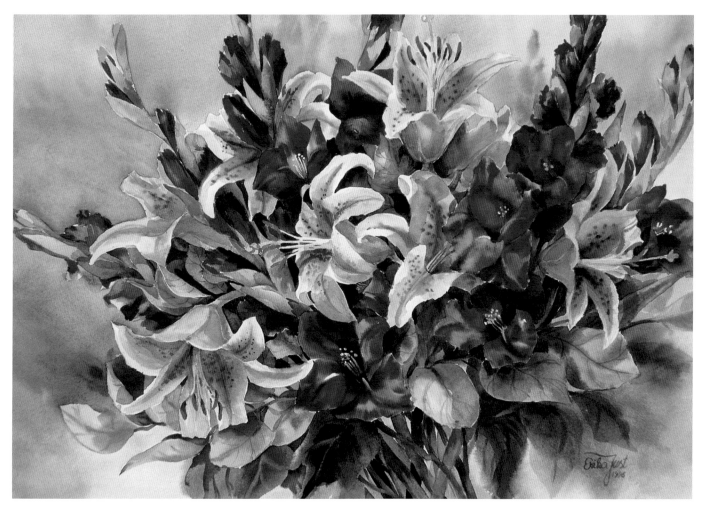

RED GLADIOLAS AND LILIES
22" × 30" (56 × 76 cm).

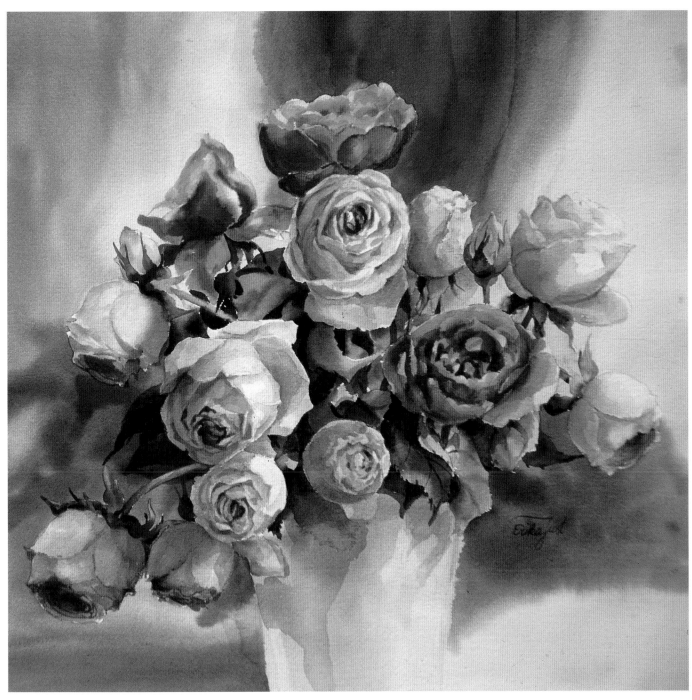

SYMBOL OF LOVE
21" × 21" (54 × 54 cm).

The "Old Roses" have been pushed aside for many decades and have been replaced by modern hybrids, but fortunately they have recently found their way back into our gardens. I noticed these old-fashioned roses in a garden near a French village and was so taken in by their subtlety and charm that I knocked at the door and asked the lady of the house if she would be kind enough to let me have a few to paint. On condition that I would give her a photograph of my painting, she gave me a bouquet of the nicest blooms. Carrying my trophies home, I placed them before the dark drapes in front of the window to let the light shine onto the heavy, drooping blossoms. This turned out to be one of my favorite paintings.

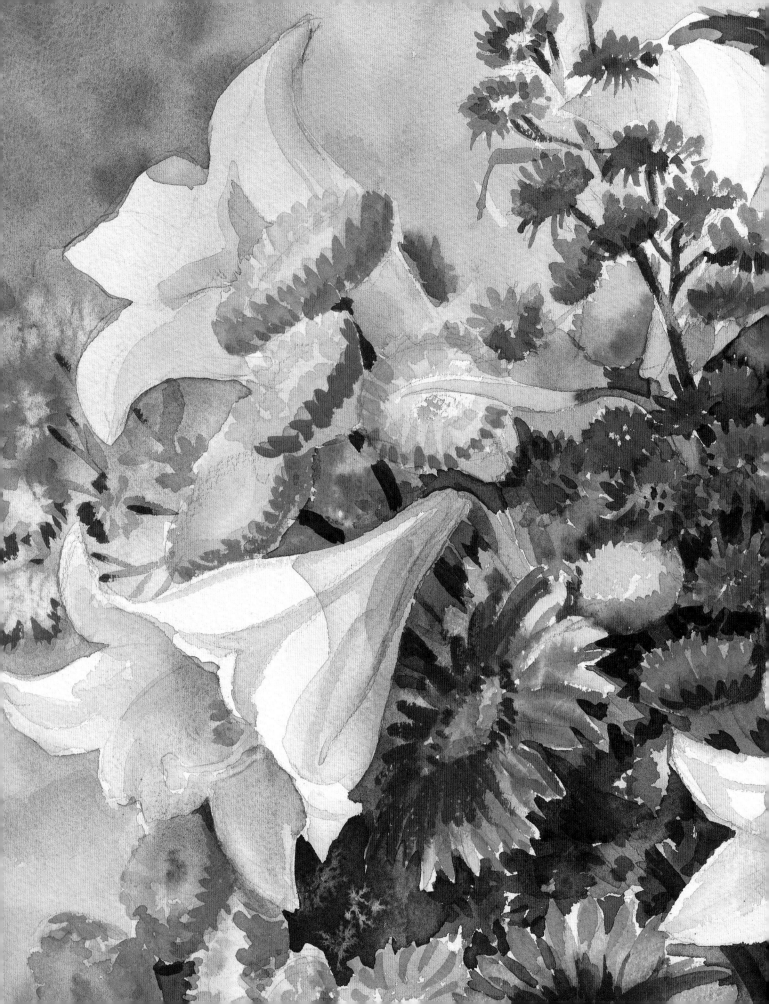

CHAPTER 4
Demonstrations

Beauty of Little Things

Whenever I walk and look around me, I see hidden treasures everywhere. It may be an old rotten tree trunk in the woods, half overgrown with a variety of plants such as moss, grass, blackberries, bluebonnets, or Indian paintbrushes. Sunlight falling through the canopy of trees illuminates these treasures with the suggestion: "Please paint me!"

● STEP 1

There are many different ways to start a painting. For this one I made a preliminary sketch with a #6B graphite pencil, which is soft and allows me to play around with shadows. This way I can work out where I want to place the darks and lights. Drawing the tree trunk slightly off-center ensures a good design. I let the light touch the leaves and grass to have them appear like lacework so that the eye is encouraged to move across the painting from the upper right toward the flowers, which are to be the center of interest.

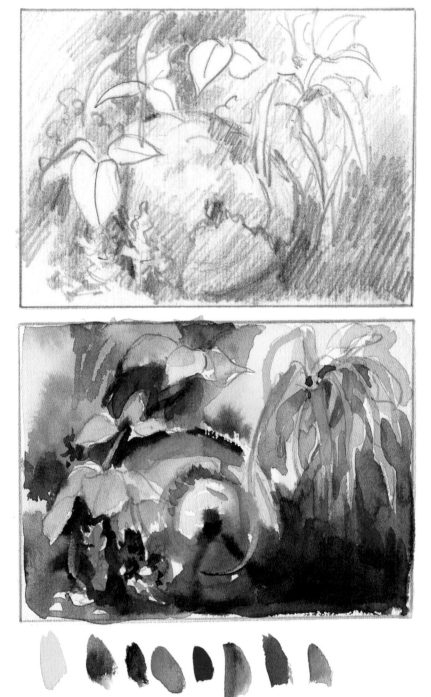

● STEP 2

The next step is a sketch to establish the color scheme. I use soft yellows with strong green hues and dark browns in order to produce the lush green weeds surrounding the tree trunk, and blue-greens for the young raspberry leaves. The yellow of the grass is repeated in the tree trunk and the red of the Indian paintbrushes shows up slightly subdued in the background, so that it is not left isolated.

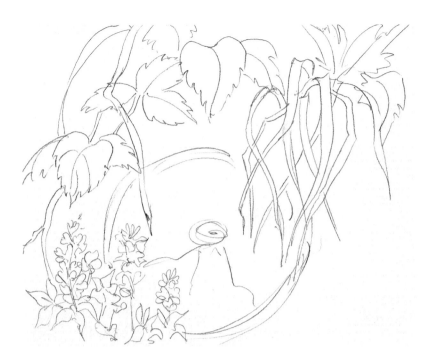

● STEP 3 (LEFT)

I decided to use 11" × 15" Arches 300-lb. cold-pressed paper. The colors I selected for this painting are aureolin yellow, sap green, French ultramarine blue, verditer blue, permanent red, burnt sienna, sepia, and yellow ochre. After drawing the design, I covered the grass, leaves, and flowers in the foreground with masking fluid, so that laying in a nice flowing wet-in-wet background would be no problem.

● STEP 4 (BELOW)

During the ten minutes it takes for the masking fluid to dry, there is ample time to plan the colors for the wet-in-wet background. Although the color scheme is basically established, I still have to decide how to break up the darks in the background to add interest.

Starting with soft greens, I added ultramarine blue and permanent red to repeat the colors of the bluebonnets and Indian paintbrushes in the background, adding a few grains of salt while the paint is still damp. Working my way around to the left side of the trunk, I add sepia to the greens to darken the background for the flowers.

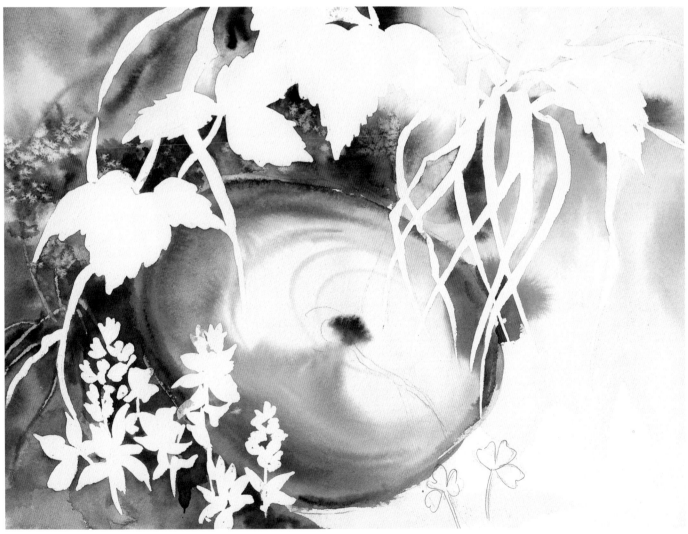

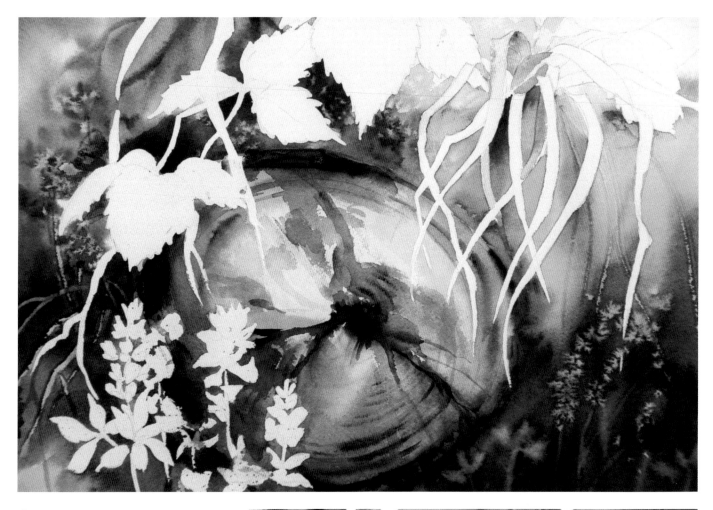

● STEP 5 (ABOVE)

Next I start on the right-hand lower corner with a loaded brush of sap green and French ultramarine blue. I put salt on the wash at the exact moment necessary to form the shapes of some weeds or flowers. To add interest, I draw a few fuzzy lines and pick out some clover leaves.

For the tree trunk I use yellow ochre, burnt sienna, cobalt blue, and sepia. I glaze over the preliminary wash with yellow ochre partially mixed with burnt sienna and cobalt blue. For the shadows I cool down the color and add burnt sienna toward the center of the trunk, to show the beginning of decay. For the cracks and bark, I use sepia. Since the trunk is not in the foreground, I am not getting into great detail.

● STEP 5, DETAIL (RIGHT)

I was lucky; after wiping off the dry salt, beautiful images of flowering weeds appeared out of the dark green background. Sap green, being a permanent dye, remained on the paper, while the salt grains soaked up the French ultramarine blue. (See "Using Salt," page 45.)

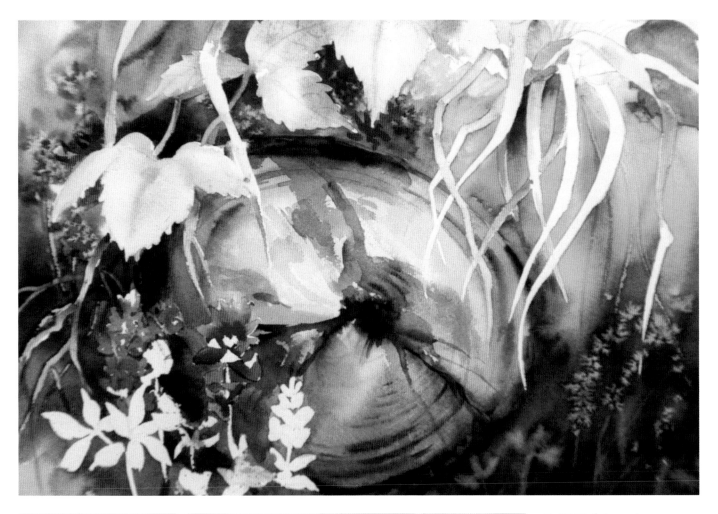

● STEP 6 (ABOVE)
I now lift the masking fluid off the dried paper in order to paint the grasses, the flowers in the foreground, and the raspberry leaves. For the bluebonnets I use cobalt blue and French ultramarine blue and for the center of the blossoms a light touch of opera, making sure that the tops of the flowers remain pure white. For the Indian paintbrushes, I use permanent red and yellow ochre.

● STEP 6, DETAIL (LEFT)
I use a light touch of verditer blue in combination with cobalt blue and aureolin yellow for the raspberry leaves, and yellow ochre and burnt sienna for the blades of grass.

● STEP 7

Drawing some more blades of grass onto the green background behind the bushel of yellow grass, I fill the negative spaces between the newly drawn blades with a soft tone of bluish green, showing depth.

● STEP 8

I glazed over the basic wash of the leaf in order to keep it crisp and to complement the soft image of the bluebonnets in the background.

BEAUTY OF LITTLE THINGS
11" × 15" (28 × 38 cm).

Pink Dahlias

I do not have a "green thumb." This is probably why I am so fascinated by flowers and why I got so excited when my dahlia plants actually started to bloom! The beautiful salmon-colored blossoms were just begging to be painted.

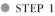 **STEP 1**
This little thumbnail sketch was done to decide on the best placement of my dahlias. I really wanted to highlight them.

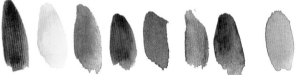

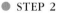 **STEP 2**
In order to demonstrate their beauty, I wanted to put the flowers against a background that was partially dark and partially light. The colors I used were opera, aureolin yellow, yellow ochre, burnt sienna, sepia, sap green, French ultramarine blue, and peacock blue.

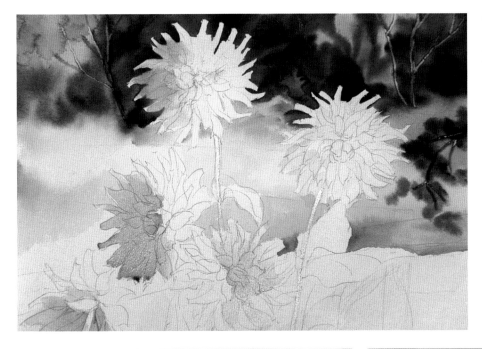

● STEP 3

I decided to use a size 17" × 22" cold-pressed Arches paper, and started by putting a soft wash in the background with sap green, aureolin yellow, French ultramarine blue, and peacock blue. With images of shrubs and trees I created a dark background for the sunlit dahlias in the upper part of the painting. Once the shine on the paper was practically gone, I scraped the distant trees into the damp paint with the brush handle. I then added a soft touch of green to the lower part of the painting.

Since the light is coming from above and behind the flowers, the blooms in the lower part of the painting are partially in shadow and are done with a cooler mixture of opera, yellow, green, and blue in front of the soft green background. The sunlit petals remain untouched. In sunlight the colors seem to be bleached out, and soft shadows enhance them.

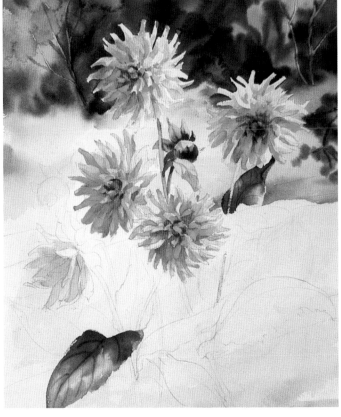

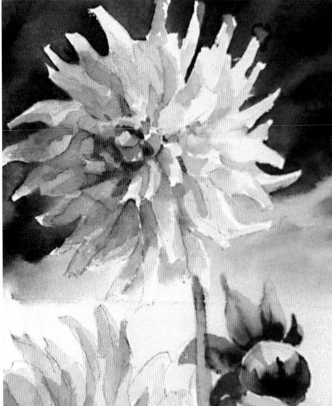

● STEP 4

Next I painted the flowers one by one. The darker sides of the blooms needed to be cooled down with a touch of green. I warmed up the midtones with opera and yellow by intensifying those two colors. Trying to focus attention on the fundamental shapes, I left out what appeared to be of lesser importance. Squinting through partially closed eyes helps to establish the essentials. Next, I placed a bud behind the blooms and a leaf at the bottom of the painting to balance the colors of the background with the foreground.

● STEP 4, DETAIL

To show the reflection of the green surroundings on the salmon-colored petals, I gave the large bloom a soft sap green glaze in the shadows on the left-hand side.

● STEP 5

Contemplating the design of the painting, I thought it would be nice to have some daisies growing underneath the dahlias to break up this section of greenery, keeping the middle part of the picture very light and the lower part darker. The pink flowers together with the white daisies weave like lacework through the painting, with the fence providing calm and direction. Paying attention to the overall design, I painted the leaves one by one, those in the background somewhat darker, tying everything together. Taking a black-and-white photograph is useful to verify whether the lights and darks are in harmony and well distributed.

I rather like the outcome. I think I have done my dahlias justice.

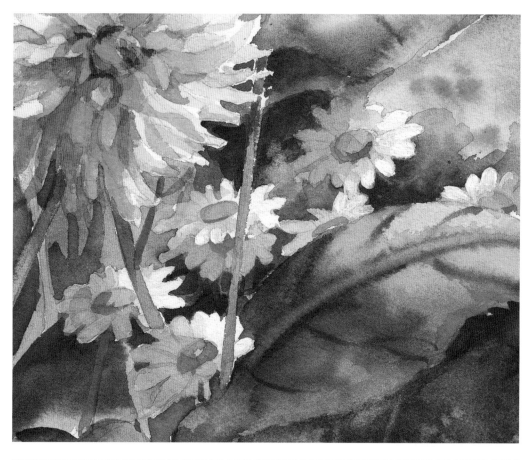

● FINISHED PAINTING, DETAIL

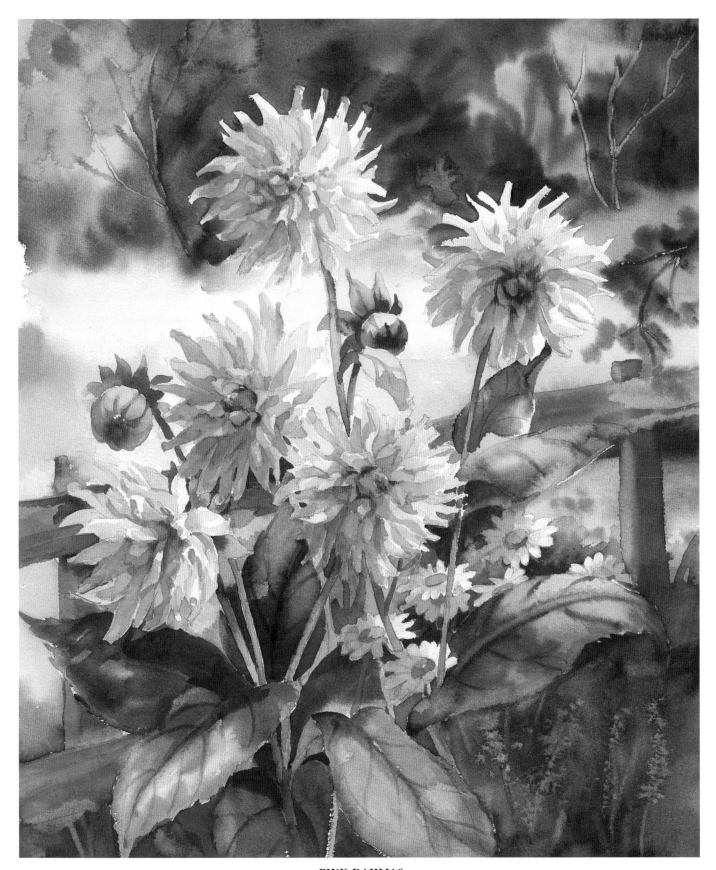

PINK DAHLIAS
22" × 17" (56 × 43 cm).
Collection of Mr. and Mrs. Muellner-Kienert.

Sunflowers

One day in spring my next-door neighbor surprised us by plowing his meadow and planting a field of sunflowers. I could not resist painting the resulting splendor.

● STEP 1

First I made a quick sketch to establish the design, positioning the flowers to my liking. I seldom stick entirely to my drawings, permitting my paintings to evolve and letting them often go beyond my initial concept. It is fun to observe their development as work progresses. In this case I changed the original design by adding one more little sunflower to the right-hand side.

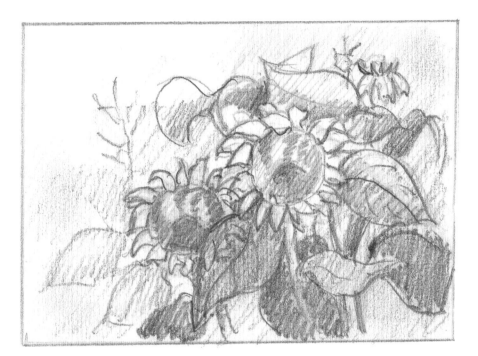

● STEP 2

Making the color sketch, I used all three yellows on my palette. The greens I made up of sap green, French ultramarine blue, aureolin yellow, and the occasional touch of burnt sienna. The green underneath the flowers worked well on the small scale of the sketch, but on the larger scale of the painting more variety of shapes and colors appeared to be required.

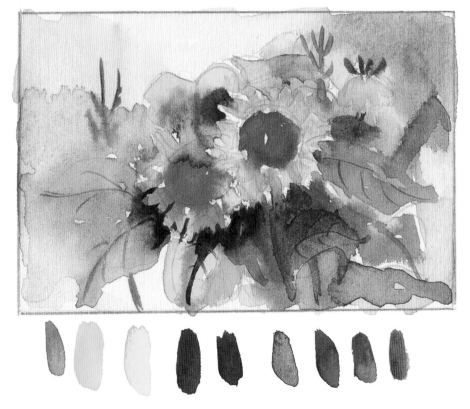

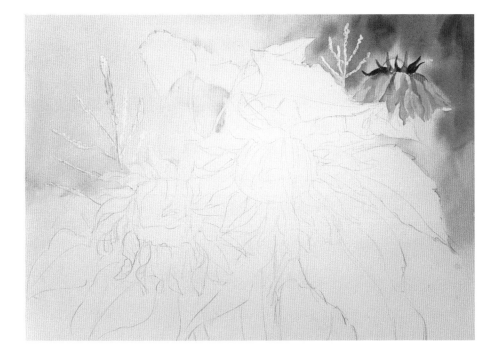

● STEP 3 (LEFT)

After I finished the drawing on 16 1/2" × 22" cold-pressed 300-lb. paper, I masked the flowers of the Indian corn plants sticking out at the top. Next I put in the background wash using cobalt, burnt sienna, and yellow ochre. There is a mountain behind the sunflower field, providing a bluish background in contrast to the vibrant yellow of the blossoms. I painted the sunflower at the right-hand top corner into the wet wash, just to establish the color. The petals were reinforced later, after the wash was dry.

● STEP 4 (BELOW)

Next I painted the top leaves, shimmering in the glare of the sun. Then I wetted the area underneath in order to place a flowering corn plant in the background. Continuing the wash toward the left-hand side, I also added a distant leaf with soft edges before the paper started to dry. A mixture of French ultramarine blue and sepia provided the cool background to bring out the vibrant yellow of the large blossoms.

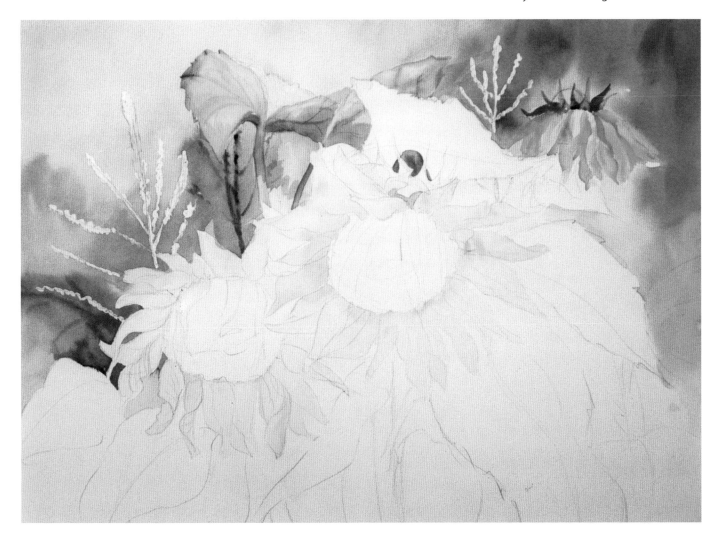

● STEP 5 (RIGHT)

Now I was ready to wet the center of the right bloom, mixing yellow ochre, burnt sienna, and sepia. Notice how softly the shadow is falling across the center of the sunflower, painted wet-in-wet. I followed by adding salt just as the shine on the paper faded away. Hopefully this would do the trick and produce little stars that look like sunflower seeds. While waiting for it to dry, I started working on each of the petals separately. The undersides of the sunlit petals are a hot orange yellow. A mixture of aureolin yellow and opera gives them a beautiful transparent glow. On the bottom part of the flower, I added blue to the yellow petals in order to let them recede slightly into the background.

● STEP 5, DETAIL (BELOW)

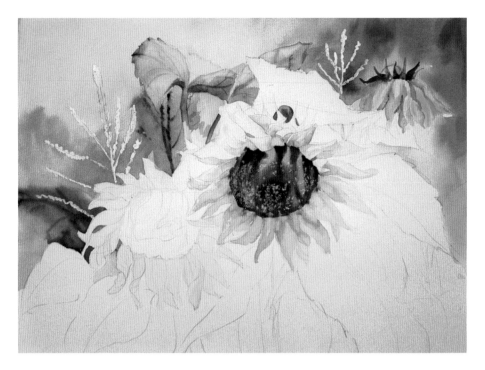

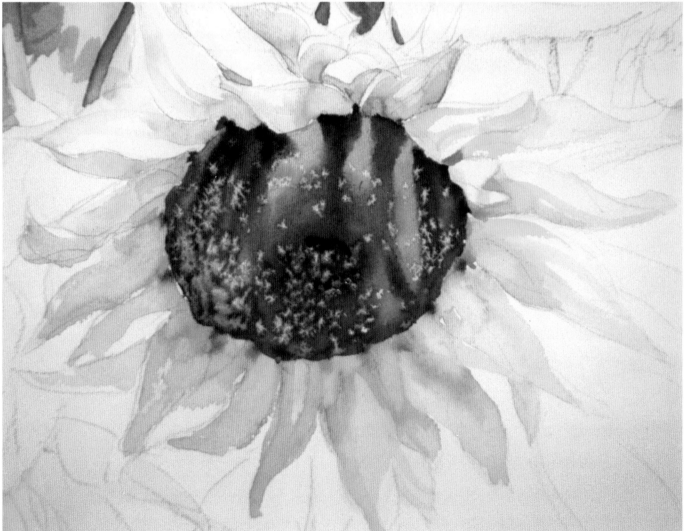

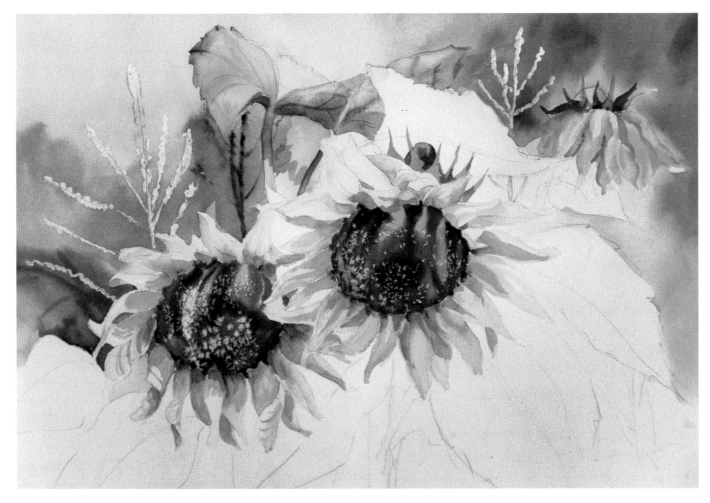

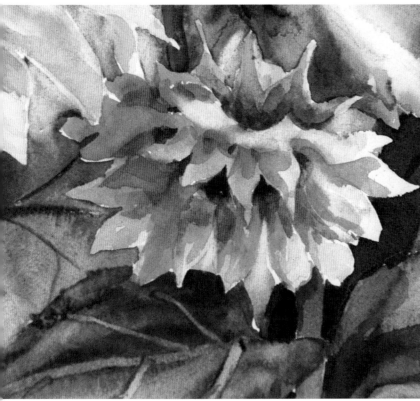

● **STEP 6** (ABOVE)

For the partially covered left bloom where less sunlight is penetrating, I followed the same procedure as for the right one, but added more pigment in warmer temperatures to the petals using yellow ochre, burnt sienna, and aureolin yellow. Tying it all together in the end, I made sure to keep it quite loose.

● **STEP 7** (LEFT)

Checking my design again, I decided to interrupt the green of the leaves with one more sunflower on the right-hand side. Painting the half-opened blossom into the shadow of the main flower, I used a mixture of aureolin yellow with a larger amount of burnt sienna, to give the blossom a much darker value.

Leaves are very important. With their cool colors they complement the flowers. It would be a mistake to regard leaves merely as green vegetation; they provide a rich supporting visual dimension to a floral. Leaves achieve this not only because of their interesting shapes, but also through their colors, which are reflected on the blooms. For this reason, I tell my students never to paint "spinach," but to make the leaves look interesting. For the colors, I rather like the combination of French ultramarine blue, sap green, aureolin yellow, and burnt sienna. A variety of techniques can be used for the veins: a darker color, yellow ochre, or the brush handle technique.

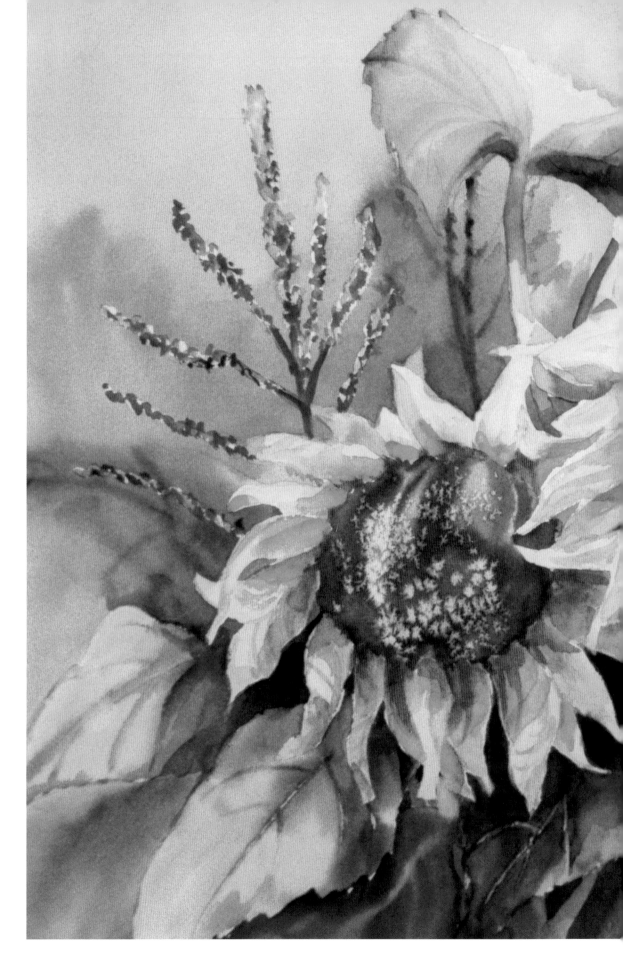

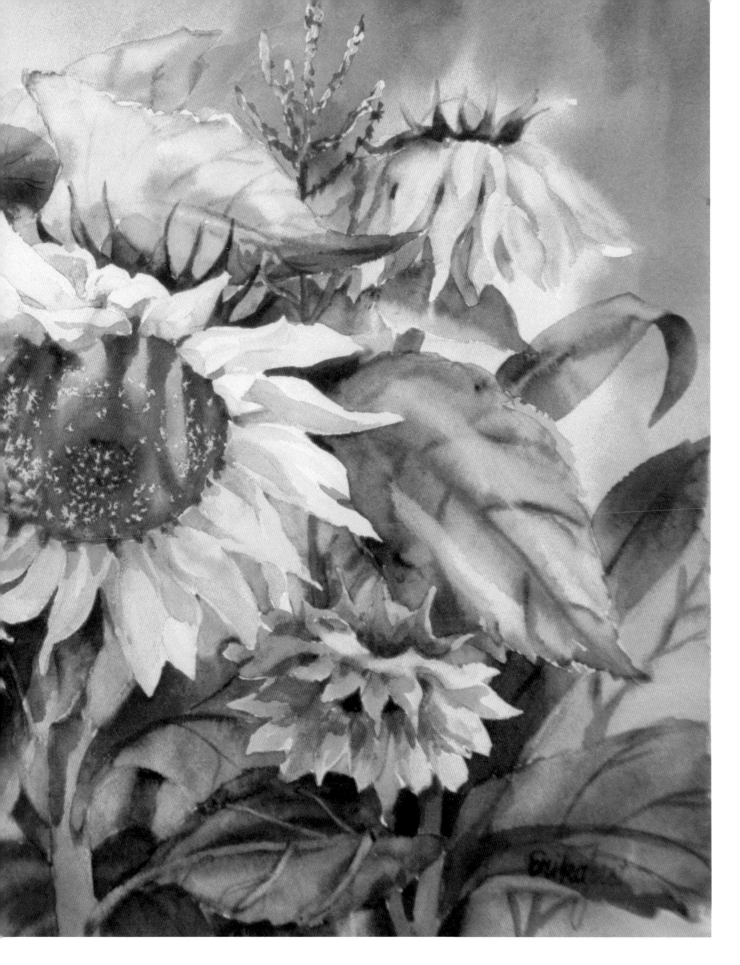

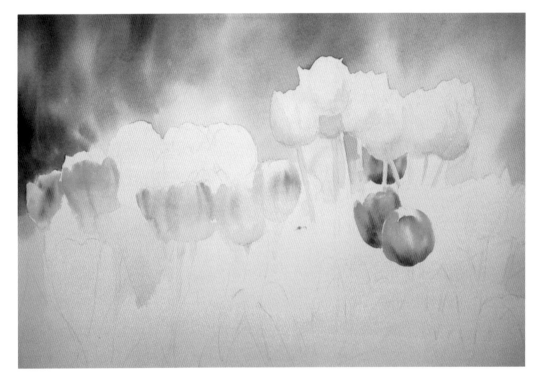

Tulips from Amsterdam

Few things are as beautiful as a field of tulips blooming in Holland during the spring: row after row of gorgeously colored flowers standing in formation, the tall white ones beside the short red ones, dark purples between pinks, tulips in almost every color imaginable. All this comes at a time of the year when just a little further south the Austrians are still skiing downhill on the alpine slopes. How can an artist resist painting these Dutch splendors?

● STEP 1

I chose an elongated piece of Arches 15 1/2" × 22" paper to accommodate a larger number of flowers and decided not to do any preliminary sketches; time was short and, being still early spring, it was quite cold. I was going to make decisions as the painting progressed and hopefully it would tell me what needed to be done.

After placing a wash of sap green, yellow ochre, and burnt sienna into the background, I added a touch of opera—just enough to repeat the colors of the tulips. For the blossoms I also used a light touch of opera with permanent red and aureolin yellow.

● STEP 2

Realizing that the background had dried too light to bring out the white tulips, I darkened it using very dark French ultramarine blue mixed with opera. The white of the paper provides the beautiful sunny glare for the blossoms. For the underside and partially for the stems, I used yellow ochre and aureolin yellow with some greens to slightly separate the tulips from each other.

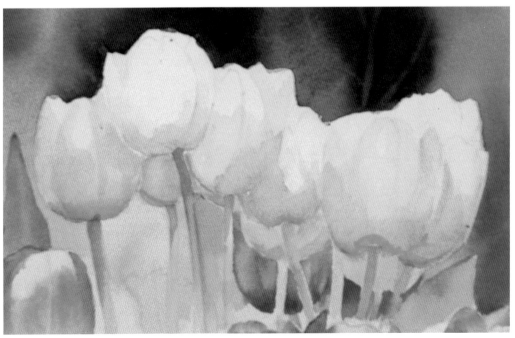

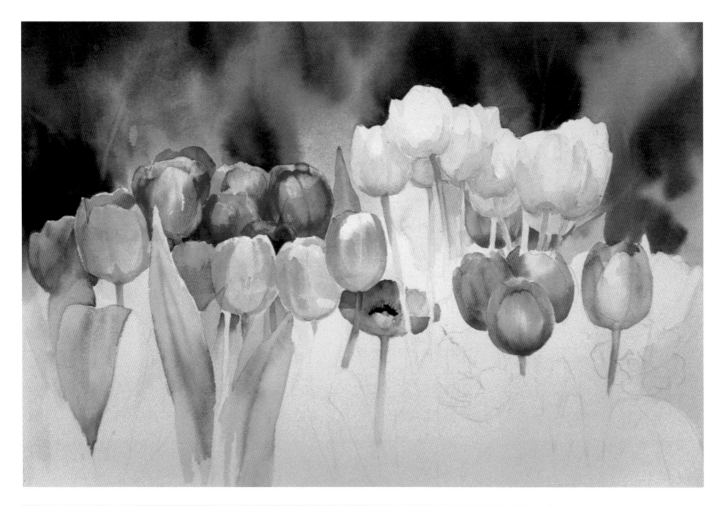

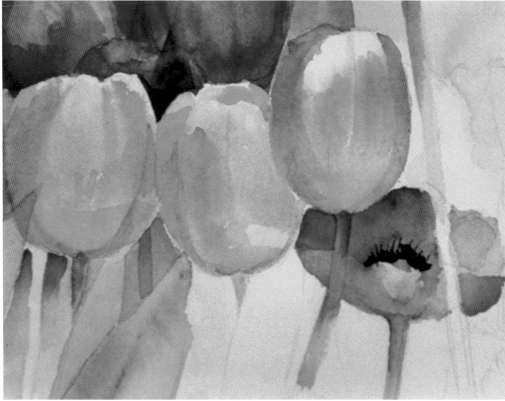

● STEP 3 (ABOVE)
The tulips in the back row are a strong cadmium red, providing a powerful contrast to the soft pink ones in the front row. To establish a good balance between cool and warm colors, I put in a few leaves using sap green and cobalt blue. A beautiful purple anemone grew hidden under the tulips, contrasting nicely to the pink and white hues.

● STEP 3, DETAIL (LEFT)

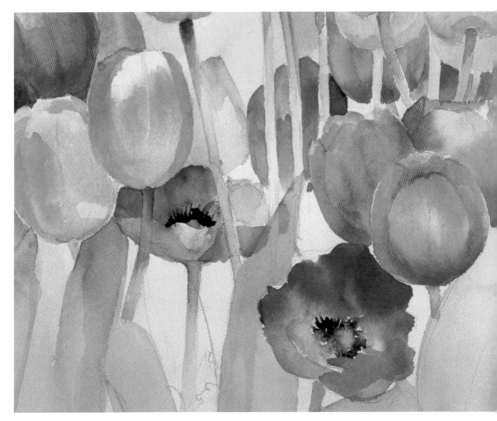

● STEP 4 (RIGHT)

After drawing a second anemone blossom on the right-hand side and putting in the three red tulips, I decided that there needed to be another dark shape in the background, beyond the white tulips. It is sometimes quite difficult to reproduce nature's brilliant colors, and it is very satisfying to succeed.

● STEP 5 (BELOW)

I had to hurry because it was getting cold and I wanted to finish the painting back home in my nice, warm studio. I put some under-paint onto the leaves to remember their colors, which were a lovely bluish green, partially reflecting the colors of the tulips. In the studio I used various combinations of blues, greens, yellows, and some reds on the spear-shaped leaves, adding one more anemone and some darks between the stems and leaves.

Once a painting nears completion, I like to set it aside for a little while. Looking at it at a later time with a fresh eye, I may see where some darks have to be enhanced, lights brought out, or shadows added.

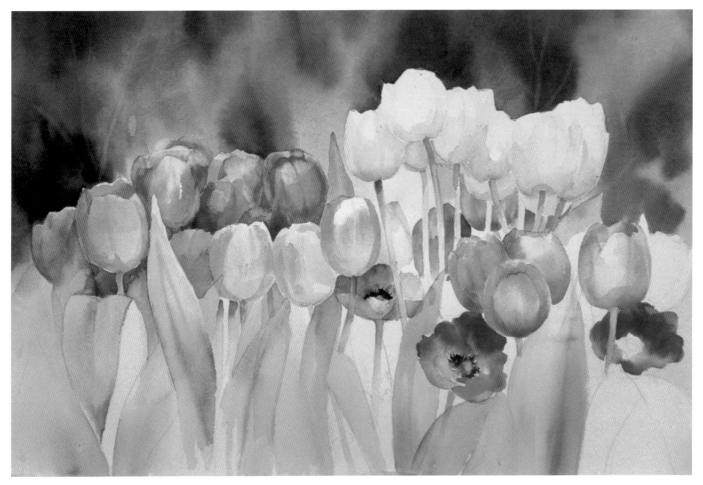

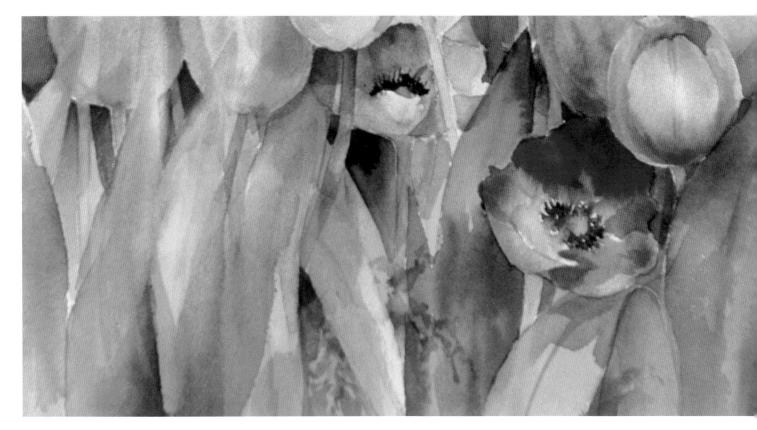

● STEP 6

Working on the green leaves, I wanted to make sure that the reddish purple color in the upper section of the painting was repeated down there, to avoid creating the impression of green "spinach." Into the little gaps between the stems I painted wonderful bright yellow and orange colors to produce the images of further tulips in the far distance.

● STEP 7

Looking at the white tulips, I noticed that I had drawn three of their stems across a dark red one, making it appear to be behind bars, which was not what I had intended. To calm the area down, I simply painted over the left stem.

TULIPS FROM AMSTERDAM
15¹/₂" × 22"
(39 × 56 cm).
Collection of
Gene and Barbara
Chiappetta.

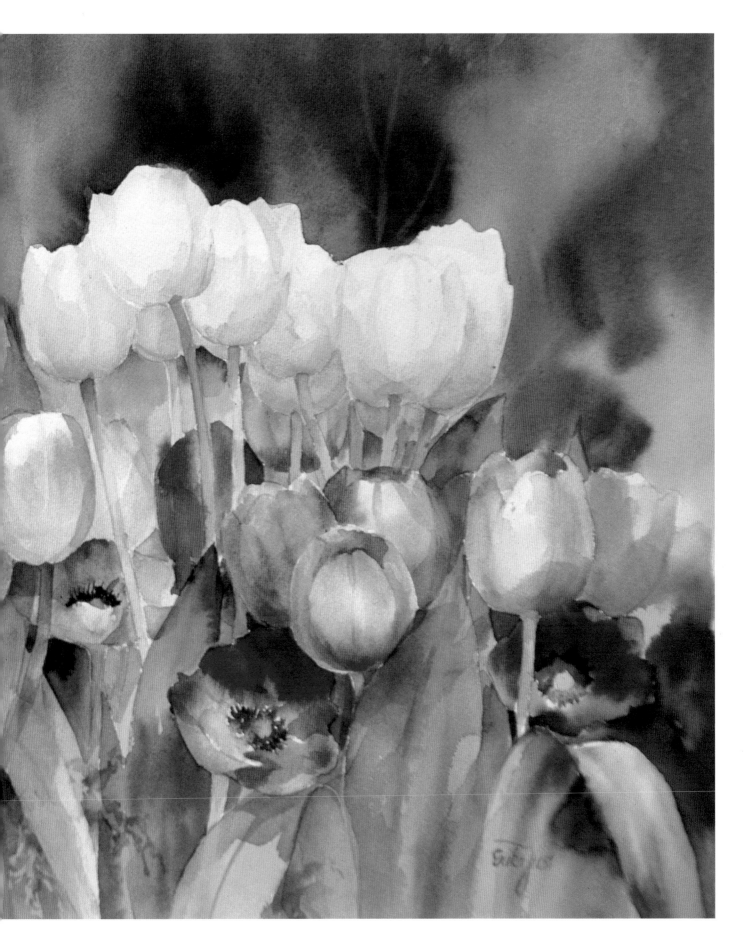

Clematis "Nelly Moser"

The clematis "Nelly Moser" is a very delicate-looking climbing perennial plant. Its heart-shaped leaves and beautiful white blossoms the size of teacups perch on extremely thin stems.

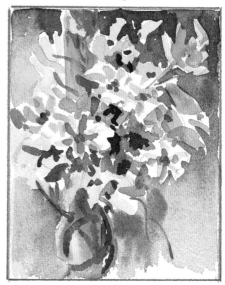

● STEP 1

Since the blossoms I wanted to paint grew in a place difficult to reach, I took a number of photographs and used the pictures to develop a good composition. After making a few thumbnail sketches, I chose one that shows the blossoms and the sunny leaves overlapping or touching each other, giving the impression of delicate lacework.

To emphasize the warm glow on the sunlit leaves at the top of the climber, I planned to use an understated grayish blue for the background, made up of Prussian blue and a touch of burnt sienna, repeating that bluish hue again on the lower part of the overgrown support post. The top of the post will be shining in warm burnt sienna.

● STEP 2 (ABOVE)
Approaching this painting the conventional way, I started to paint the first blossoms and leaves separately. Using French ultramarine blue and magenta, I established the color of the petals in the shadow. The sunlit ones I touched with a very soft yellow ochre. For the leaves I used a mixture of yellow ochre and sap green, and a light touch of permanent red around the edges.

● STEP 3 (LEFT)
After painting the sunny leaves at the top of the layout, I painted the little ruffles on the petals on dry paper to give them a crisp appearance. In the center parts of the blossoms, I used yellow ochre for the light parts and magenta with sepia for the dark portions. I added a few leaves underneath the petals to establish the darks and midtones of the painting.

STEP 4 (RIGHT)

After covering the thin stems, leaves, and edges of the flowers with masking fluid, I painted the dark background without disturbing what was already on the paper. To achieve the warm color of the wooden fence post, I used yellow ochre and burnt sienna. To show the wood grain, I drew vertical lines with sepia into the wet under-paint of the post.

STEP 5 (BELOW)

To show depth, I toned down the left side of the background and painted some leaves onto the wet paper. Their soft edges produced a nice contrast to the hard-edged leaves and blooms in the foreground. After the paper was dry, I added some dark gray, crisp shadows in the left upper corner.

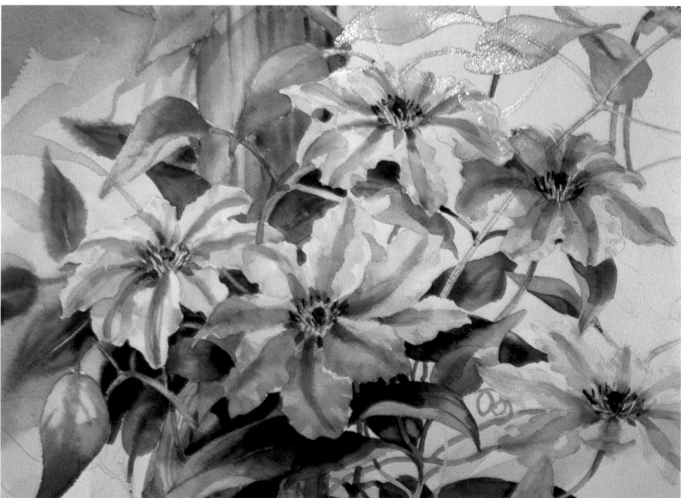

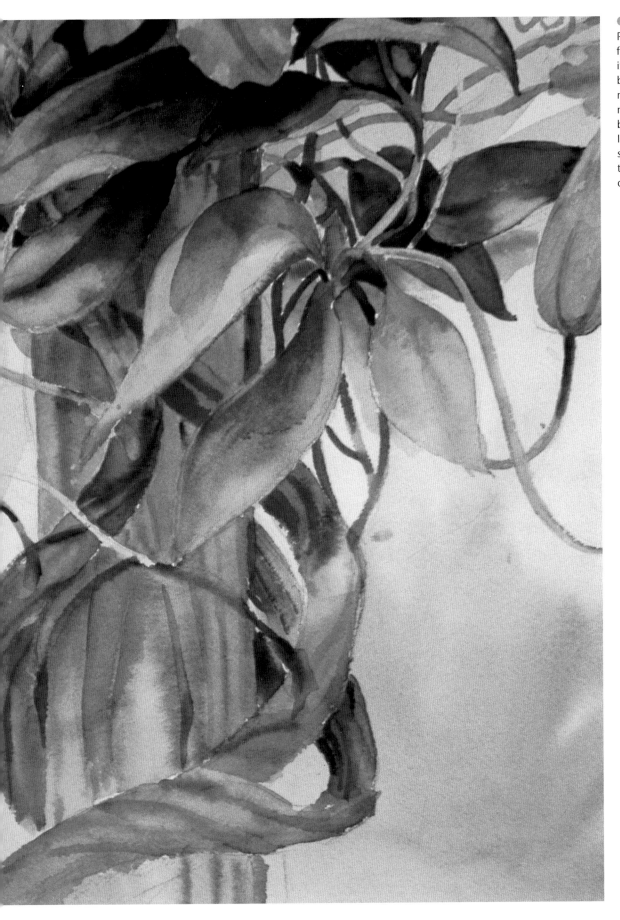

● STEP 6
Painting wood is
fun to do and I love
it. The warm hue of
burnt sienna glows
next to the cool
mixture of Prussian
blue and sepia.
I added a touch of
sap green in order
to repeat the color
of the leaves.

● STEP 7 (RIGHT)
After painting the background
and letting it dry, I decided
to give my design more depth
by wiping the image of some
leaves out of the dark back-
ground. I used masking tape
and wiped the paint out with
a soft, wet tissue.

● STEP 8 (BELOW)
Pulling the masking tape off,
the likeness of some light
colored leaves appeared in
the dark background.

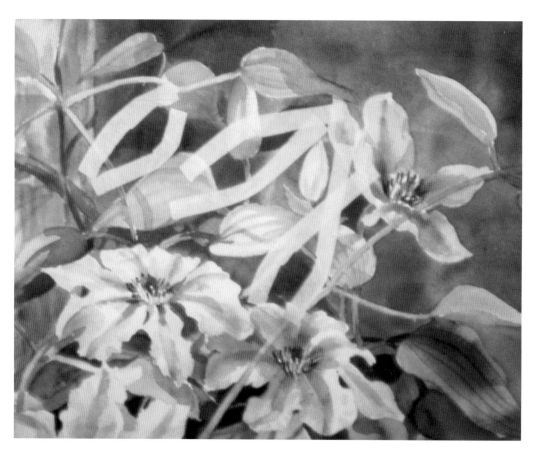

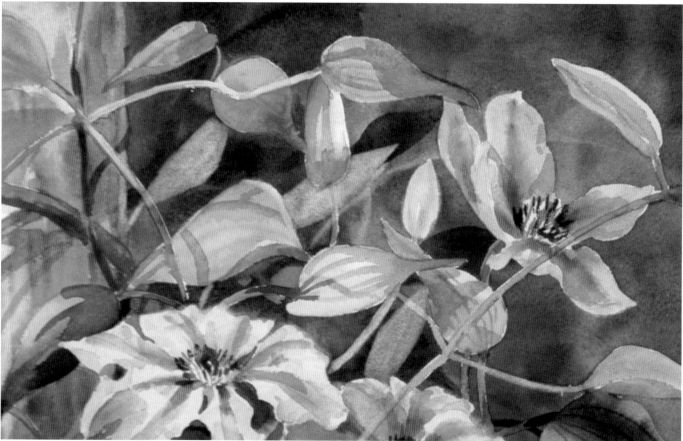

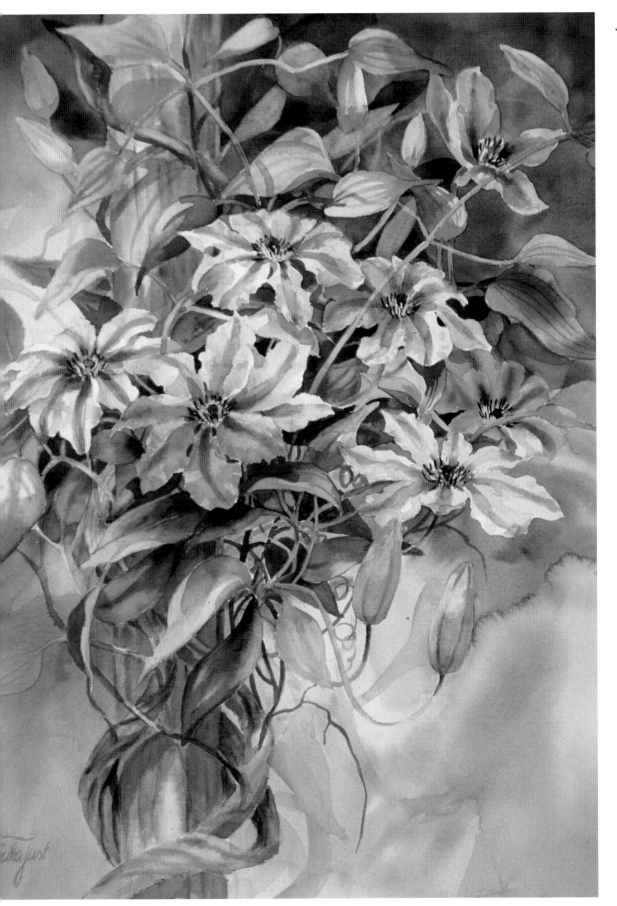

**CLEMATIS
"NELLY MOSER"**
21" × 16"
(54 × 40 cm).
Collection of
Mr. and Mrs.
Muellner-Kienert.

White Gladiolas

There is nothing quite like the effect of sunlight dancing across the petals of white flowers to stimulate one's creativity. Seeing these gladiola blooms in the sunshine, I wanted to emulate that effect.

● STEP 1

Gladiolas usually have about eight to ten blossoms growing close together on a yard-long shoot with buds at the tip. I like to look at things from various perspectives, so instead of drawing the stems standing up, I decided to have them point toward the viewer, coming out of the dark, left upper corner. Next I decided what colors to use. After making a few color sketches, I selected a bluish background, interrupted with soft yellows and orange.

● STEP 2 (LEFT)

Gladiolas are quite difficult to draw. They grow very close together, they twist and turn and overlap each other, and all the blossoms face in one direction. Making a sketch helps to study the structure of the flower.

After I transferred my sketch to a large sheet of Arches paper, I decided on a monochromatic blue color scheme for my painting. With a loaded brush I painted a light mixture of Prussian blue, French ultramarine blue, and a touch of sepia around my gladiolas to gray down the pure white of the paper in the background, establishing the color of the flowers' shadows at the same time.

● STEP 3 (BELOW)

Now comes the fun part, which is bringing out the flowers. Some of my students start off by asking what color they should use for the white blooms, not realizing that the white of the paper is the white they are looking for. The background painted around the flowers will emphasize their brilliant white. Only the blossoms in the shade are given a soft wash; after it is dry they are glazed over with a slightly darker hue, looking for crisp edges. Since the surrounding colors are reflecting on the petals, their shadows have the same hue.

Before starting to paint the flowers, I covered their stamens with masking fluid and let it dry. I worked each flower separately.

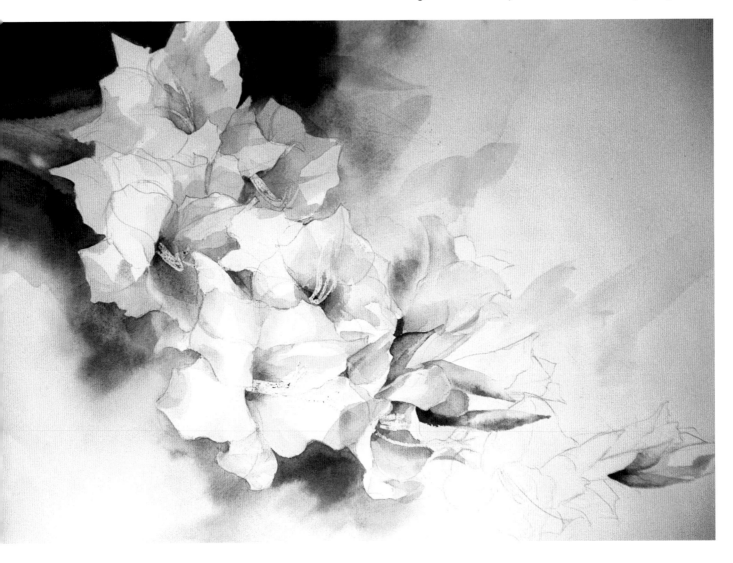

● STEP 4

After removing the masking fluid I painted the stamens and crisp shadows on the blooms, working on dry paper. Next I overlapped parts of the shadows again with another light gradation of background color to achieve greater luminosity and the appearance of crumpled white silk. Adding yellow, I warmed the color in the centers of the flowers, and with a strong orange made up of aureolin yellow and permanent red accentuated the contrast. Painting the background first before starting on the blooms forestalls the tendency to paint the white of the flowers and ensures that they do not lose their white brilliance.

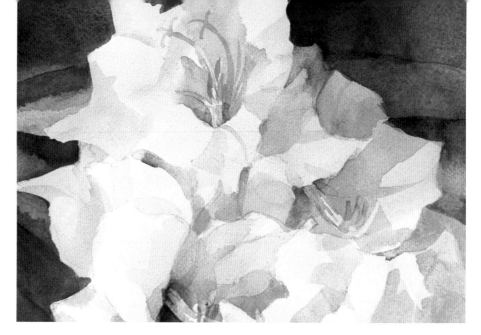

● STEP 5

On the lower end of the branch there is less light on the flowers; therefore, I used less yellow ochre and bluer hues in the shadows. To bring out the darker blossoms, I reversed the colors and painted the background with a soft touch of aureolin yellow mixed with yellow ochre. I glazed over the blooms until I achieved the desired darker hue.

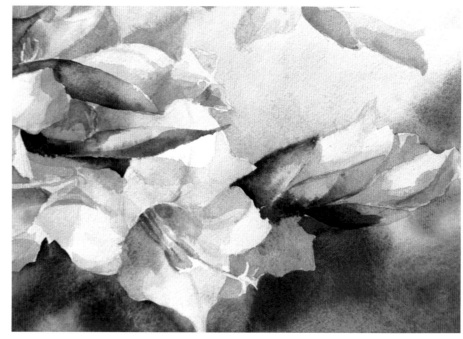

● STEP 6

Stepping back to check my design, I found that I needed more blossoms in the upper half of the painting to add depth. Painting the upper background darker would bring out the new blossoms, but would make the painting heavy, which I wanted to avoid. So, I decided to give the additional flowers a darker value as compared to the one in the foreground. Glazing over the petals, I achieved a wonderful translucency. Touching up the space between the two stems with yellow and orange pigment, I achieved an image of depth.

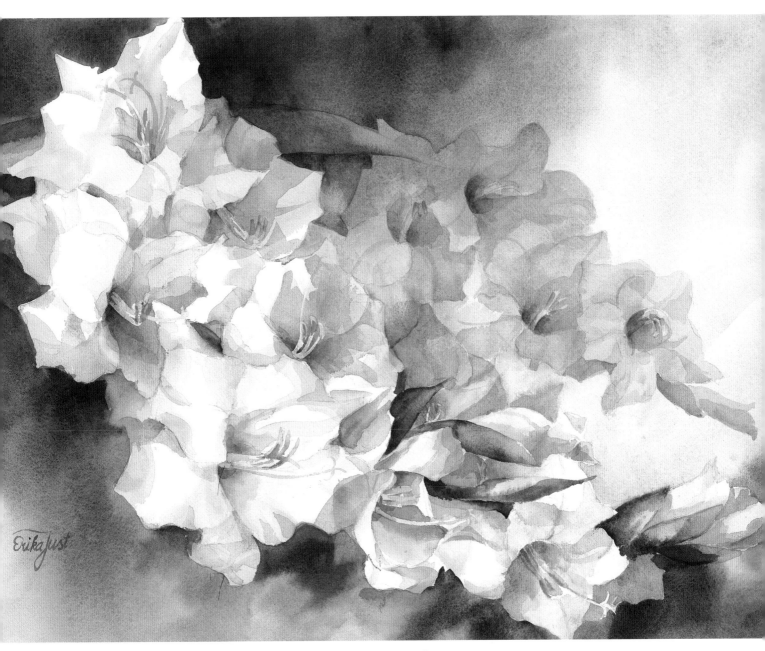

WHITE GLADIOLAS
15" × 21" (38 × 53 cm).

Irises

The colors of these fascinating flowers range from pure white to yellow, burnt sienna to sepia, and light blue to purple. The top petals of a flower may be white as snow while the lower petals may exhibit any other color, or the upper and lower petals may have the same color at different values. Almost any color or color combination imaginable exists in nature.

During a walk I noticed irises in front of a log cabin with the white of the flowers glowing in the sunshine and the deep purple of their lower petals corresponding beautifully with the warm wood of the log cabin. I made a quick color sketch and pinched one of the flowers together with leaves so that I could draw them in my studio. I hurried back to make the painting while the image was still fresh in my mind.

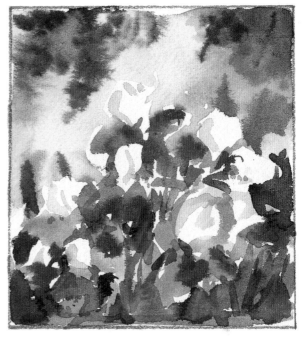

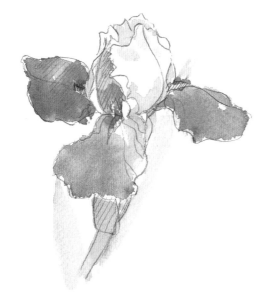

● **STEP 1** (ABOVE LEFT AND LEFT)
Although irises appear complicated in appearance, they really have a simple structure. An iris is composed of six large petals, three growing upward and three sideways or downward, depending on the species. They look like little ballerinas.

● **STEP 2** (ABOVE)
The yellow, green, and purple combination represents a most pleasing orchestration of colors. In order to achieve variety in the background, I used aureolin yellow for the cooler side, yellow ochre and burnt sienna for the warmer side, and sepia in combination with sap green and a touch of purple for the darker part at the bottom of the painting. Details are worked out later.

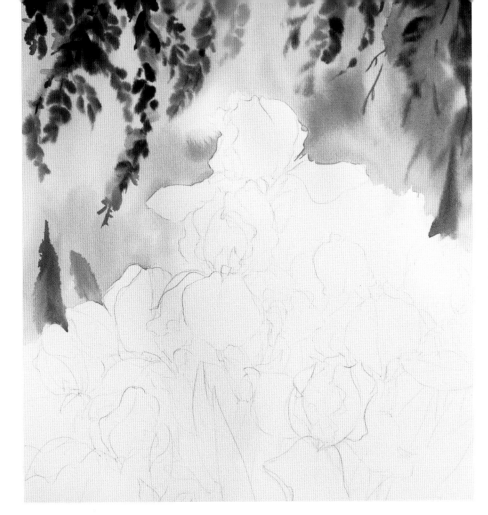

● STEP 3 (LEFT)

After completing the drawing, I dug deep into my palette, using aureolin yellow, yellow ochre, burnt sienna, French ultra-marine blue, cobalt green, brilliant purple, cobalt blue, sap green, sepia, magenta, and cadmium orange for the final touch. For the wet-in-wet background, I brushed in strong colors and "drew" some over-hanging greenery into the upper part of the painting. The opaqueness of cobalt green added interest. To bring the colors of the irises into the background, I put in a touch of purple to indicate some tiny blossoms.

● STEP 4 (BELOW)

I like the look of spontaneous brushstrokes. Using a mixture of cobalt blue with a little bit of magenta, I gave the paper just enough color to tone down its whiteness. Some of the brushstrokes will remain on the white petals and give them a transparent look.

STEP 5 (RIGHT)

At this point I began to paint the flowers. For the shadows I used a combination of blues, purple, and the warm yellows from the background, keeping in mind that white always reflects the surrounding colors. Wetting the dark petals one at a time, I let the paint flow into the water to mingle on the paper rather than mixing it on the palette. In this manner, the petals give the impression of silkiness and brilliance. A beautiful raspberry appeared just at the right spot on the dark petal of the second flower; it's an exciting process to watch.

STEP 5, DETAIL (BELOW)

I softened the edge of the lower petals against the background to give the impression of distance.

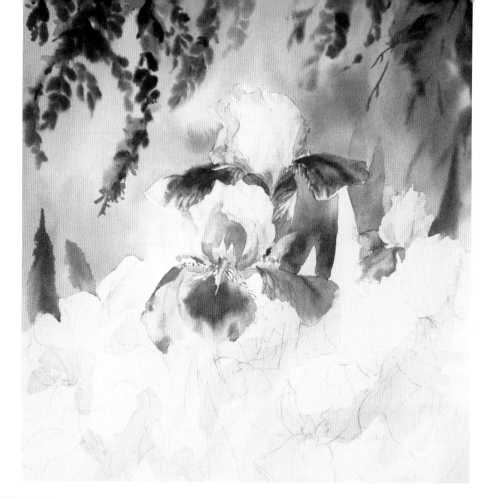

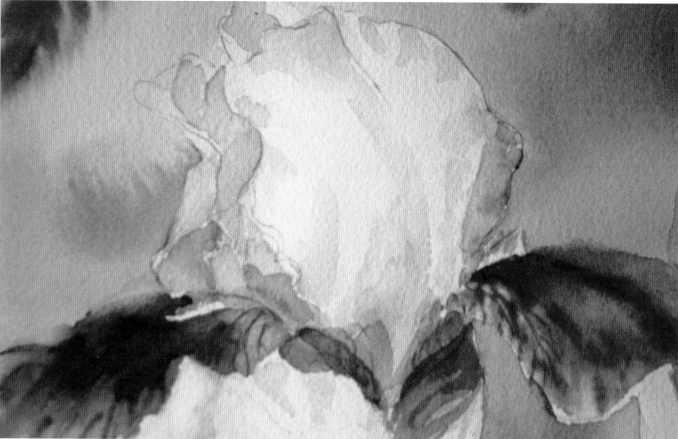

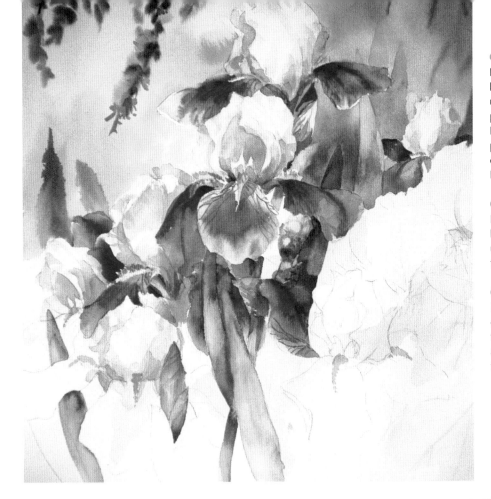

STEP 6 (LEFT)

Now I am working my way down to the left-hand side, making sure that some of the underlying brushstrokes remain on the white petals. As a reflection of the background, I dropped a light touch of yellow into some partially wetted areas. To balance the colors of the background with those of the leaves, I painted some of them at this time.

STEP 6, DETAIL (BELOW LEFT)

In spite of the new glazing, the underlying brushstrokes are still visible on the white upper petal, which is partially covered by the dark purple-blue petal.

STEP 6, DETAIL (BELOW RIGHT)

Painting the bud, I glazed some of its purple over part of the white petal, as a reflection of the surrounding colors. For the same reason and to avoid the "spinach" effect, I also gave the leaves a light touch of purple.

● STEP 7 (RIGHT)

Working on the flowers and leaves on the right-hand side, I cooled the value of the leaves down to keep the lower right corner dark and soft, giving the impression of foliage under the blossoms. Finally I decided to make that area more interesting and included a white iris amidst the others in the dark shadow.

● STEP 7, DETAIL (BELOW)

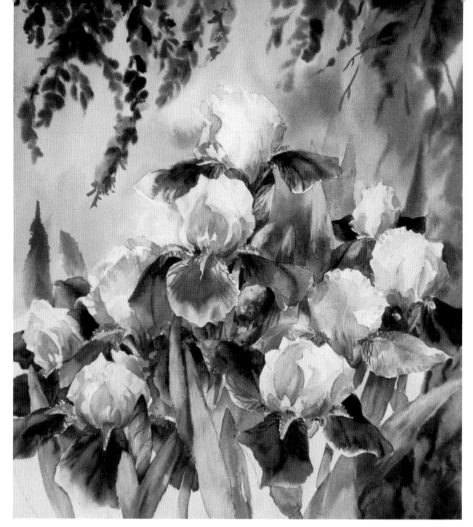

IRISES
19" × 16 1/2" (49 × 42 cm).

Nasturtium

One day I noticed a nasturtium growing among the rosebushes in front of my bedroom window. A bird had probably dropped a seed, which liked my rose bed so much that it set up shop in it. Pretty soon nasturtiums took over. They were everywhere: up the rosebushes, around the window frames, along the walls. I was grateful for the bird's gift and arranged a bouquet of the flowers in a lead glass bowl— I could not wait to paint them! Their splendid colors vary from light yellow to orange and from red to burnt sienna. Their blue-green leaves enhance the hot colors of the blossoms even more. For me, the challenge of painting flowers is to fully capture the playfulness of nature with all its forms and colors.

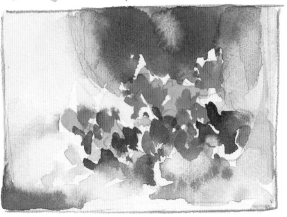

● STEP 1

My lead glass crystal vase is shaped like a basket. With the bouquet of nasturtiums nicely arranged in the bowl, I placed it on a lace tablecloth and made a few drawings of its overall shape until I was satisfied with the setup. To better familiarize myself with the plant, I studied the blooms in detail.

● STEP 2

For the color sketch I used permanent yellow, aureolin yellow, yellow ochre, burnt sienna, sepia, magenta, opera, sap green, and all the blues from my palette. The nasturtium is exceptionally brilliantly colored, and even the brightest yellow and orange pigment is not quite bright enough to do it full justice. The brightest orange is achieved by mixing opera with aureolin yellow, colors that will let my flowers "sing" and jump out of the blue background.

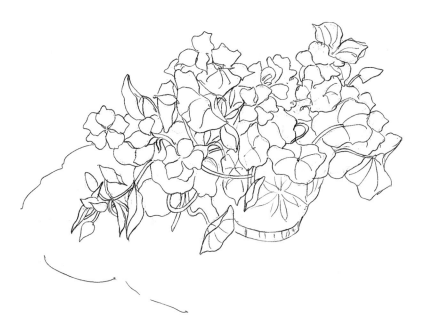

● STEP 3 (LEFT)

After doing a thorough study of the blossoms, it was relatively easy to draw flowers facing out of the basket in all directions. Before applying the background wash, I covered the outer edges of my sketch with masking fluid. I was planning to draw the details of the tablecloth at a later time.

● STEP 4 (BELOW)

Instead of mixing the background colors on the palette, I let them blend on the wet paper, allowing plenty of time to let the pigments do their work. It is fun to observe how colors ooze into each other. I used French ultramarine blue and magenta for the blue side, and yellow ochre, permanent yellow, and a touch of permanent red for the sunny side on the left. The blue pigment and yellows will be repeated in the leaves at a later time.

After the background wash had dried, I removed the masking fluid and started painting some of the flowers and leaves.

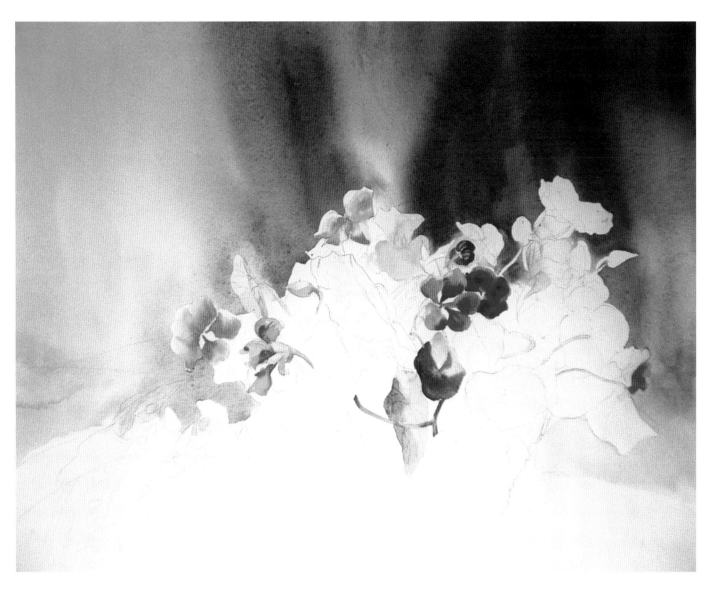

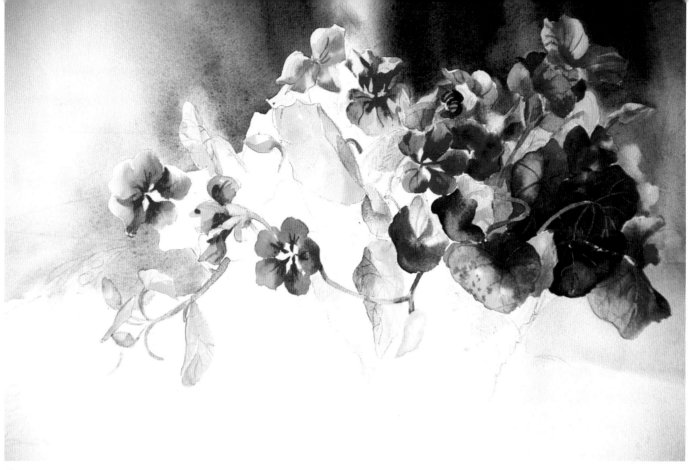

● STEP 5

The sunny leaves provide a strong contrast to the blue-green leaves in the shadows. The colors of the blossoms are repeated in the stems.

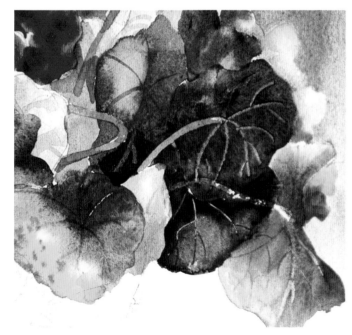

● STEP 5, DETAIL

Using the "brush handle" technique, I scratched the dark veins into the wet paper to let pigment collect in the little grooves, while for the light veins I scraped some of the pigment out as soon as the paper was slightly drier.

● STEP 5, DETAIL

To create the luminosity of the strong, bright sunshine on the blossoms, I left the edges of the petals white and applied the intense hues toward the centers of the blooms. I had spared the areas of the flowers outside the area of the first wash.

● STEP 6

The glare of the sun on the outer edges of the flowers came out just beautifully. I painted the shadows using dark orange and permanent red rather than using a cooler hue.

● STEP 7

To indicate the lead glass crystal basket, I filled the background between the flowers and leaves with a light wash of French ultramarine blue mixed with a touch of magenta. This gray tone further enhanced the color intensity of the blooms.

● STEP 8

I used the same color mixture for the tablecloth as I did for the crystal basket. A few accurate lines show the pattern of the lacework; a few loosely done brushstrokes are sufficient to indicate the rest of the tablecloth.

● STEP 9

The little lead crystal vase is translucent, not transparent. The stems of the flowers are not clearly visible through the pattern of the glass; just a soft tint of green in the crystal indicates their existence. To avoid drawing attention away from the flowers, I depicted the crystal bowl somewhat vaguely, letting the soft yellow of the leaves and blue shadow of the vase reflect on the tablecloth.

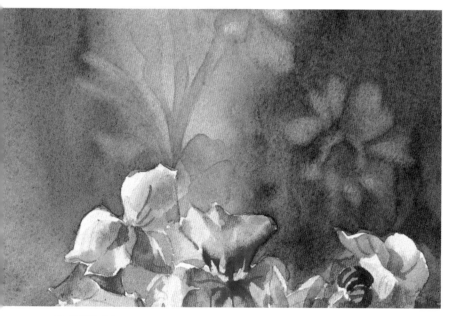

● STEP 10

Now was the time to determine whether or not the painting was finished. The colors and overall design looked good; however, the transition from the bouquet of flowers to the background was not quite to my satisfaction. I used a wet brush to pick the images of a few flowers out of the background and glazed the shapes of leaves around them. I was fond of the painting and did not want to put my brush down yet, but good sense prevailed. I made the final decision, stepped back, and enjoyed my finished work.

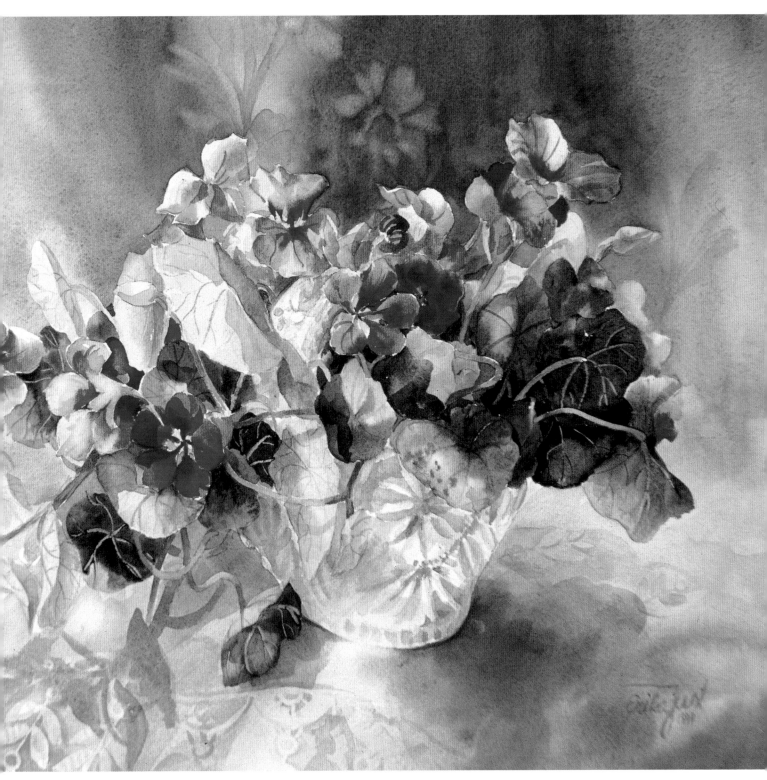

NASTURTIUM
$17^1/2" \times 21^1/2"$ (44 × 55 cm).

Flower of Gods, Flower of Love

I enjoy feasting my eyes on the abundance of colors in flower shops, and always consider the possibilities of an unusual arrangement. Once I saw a bucket full of magnificent sunflowers beside a large bouquet of yellow roses colored like fresh lemons. The combination of sunflowers, which were once worshipped by the Incas of Peru as the living representations of the Sun God, in union with roses, which represent the ultimate tokens of love to us, was such a striking arrangement that I decided to paint them.

Being a "pack rat," I had collected all sorts of "whatchamacallits" in my studio. Using some dry leaves of grass, a stick of bamboo with a yellow ribbon, a few large decorative leaves from the garden, and those magnificent yellow flowers from the shop, I started to paint.

● STEP 1 (ABOVE)
I worked out the positions of the two different types of flowers with special regard to the way sunshine would highlight the blooms. The effect of the sunlight on the flowers would be strengthened by the darks surrounding them. For the color sketch I used verditer blue, cobalt blue, and French ultramarine blue in combination with sap green for the leaves. I painted the flowers and grasses with aureolin yellow, permanent yellow, yellow ochre, burnt sienna, sepia, permanent red, and brown madder. I wanted the blooms to form a unified shape with the ribbon, containing different yellows turning from greenish to orange hues. Medium values would dominate the finished painting.

● STEP 2 (RIGHT)
I first drew only the flowers and ribbon, planning to introduce further shapes later on during the painting process. I find it is a great challenge to allow a painting to develop freely on its own.

● STEP 3 (ABOVE)

In order to concentrate on the background without having to worry about the sunlit flowers, I covered the upper petals with masking fluid. After it had dried, I wetted the entire upper part of the paper and started with verditer blue and cobalt blue in the upper left-hand corner, allowing the colors to lighten gradually toward the sunflower blooms. For the right-hand upper corner I used a darker mixture of blues with some yellow ochre and allowed the pigments to blend on the paper.

With the paper in the perfect state of dampness, I used yellow ochre, burnt sienna, and sepia to paint some blades of grass on the left-hand side, and repeated the dark blue hue of the right-hand upper corner on the left side of the second sunflower to create the impression of darkness lurking behind the bouquet.

● STEP 3, DETAIL (LEFT)

After letting the paper dry out completely, I used a transparent mixture of aureolin yellow and Prussian blue to glaze the shapes of the leaves over the background, and used sepia to paint a twig over the newly created leaves.

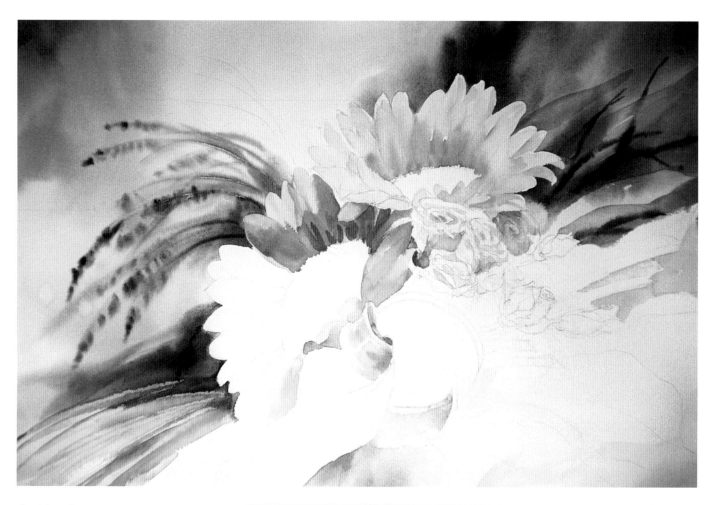

● STEP 4 (ABOVE)

Working on the sunflowers, roses, and ribbon simultaneously, I gave the roses a greenish-tinted yellow hue to achieve a marked contrast between them and the sunflowers, which I painted in a strong orange hue. In the ribbon I combined both colors. Using aureolin yellow mixed with very little permanent red in a light value, I painted the petals of the sunflowers and added some sap green to achieve a cooler shadow in the darker bloom.

For the roses I used sap green instead of permanent red, enhancing the cooler color gradually toward the darker area. To bring the background color into the main subject, I used a touch of verditer blue in the ribbon.

● STEP 4, DETAIL (RIGHT)

I painted the hidden rose under the sunflower with a darker wash mixed with aureolin yellow, sap green, and Prussian blue. The sunlit roses are partially white on top, with the paper remaining untouched to show the brilliant glow of the bright sunshine on the petals. After the paper had dried out, I added shadows to the flowers to show depth.

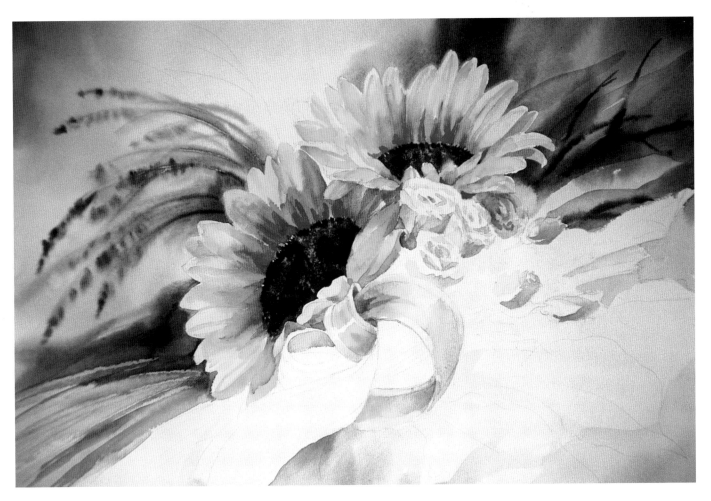

● STEP 5 (ABOVE)
Starting on the centers of the sunflowers, I wetted the paper and applied a heavy layer of burnt sienna and yellow ochre with a lot of sepia. As soon as the shine of the water on the paper was nearly gone, I sprinkled salt over the fresh paint and waited for the grains to absorb some of the pigment. After the paper was completely dry I brushed off the salt, and sure enough, little stars appeared, representing the seeds of the sunflowers. To achieve a good balance between the yellows, I did some more work on the ribbon.

● STEP 5, DETAIL (LEFT TOP)
The effectiveness of the salt on the centers of the sunflowers is clearly visible. Each grain of salt has absorbed some pigment of sepia off the surface of the paper without affecting the previously applied burnt sienna.

● STEP 5, DETAIL (LEFT BOTTOM)
I painted the knot in the ribbon with a "hot" mixture of yellow and permanent red, cooling it down with sap green to draw attention to it.

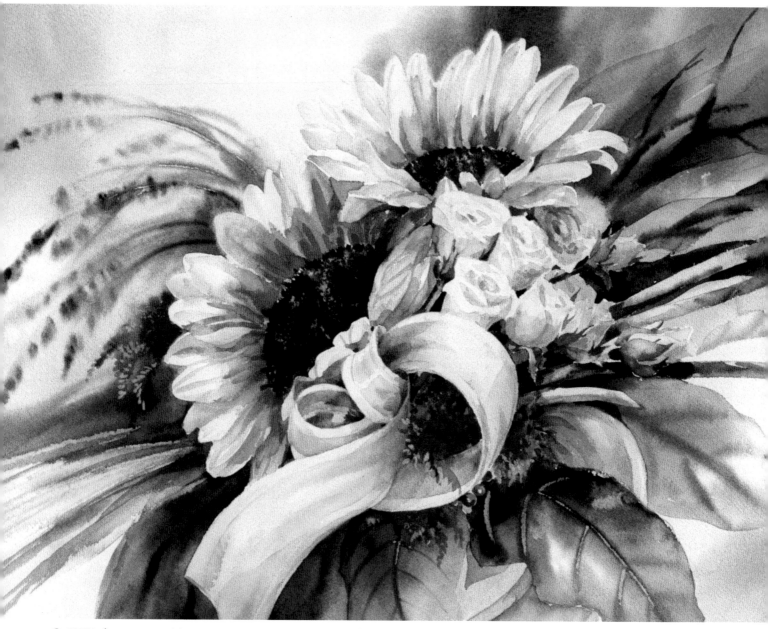

● STEP 6 (ABOVE), DETAILS (OPPOSITE)

While painting the yellow ribbon, I decided that some purple would produce a beautiful contrast to the yellow blooms and green leaves. Applying a mixture of brilliant purple #2 and verditer blue behind the ribbon and the petals on the left-hand side of the lower sunflower created the desired effect.

For the leaves I used all the blues of the upper right-hand corner plus yellow ochre and burnt sienna. I like the opaque quality of these two colors over transparent paint. I painted the leaves very loosely, since their coolness and darkness should merely complement and emphasize the importance of the flowers and ribbon. Using a much darker hue to let it recede into the background, I placed the other end of the yellow ribbon among the leaves and twigs on the right-hand side.

To increase the impression of depth and give the bouquet a more three-dimensional appearance, I further darkened the background behind the leaves. It is a lot of fun and most rewarding to be able to develop a painting while the work is in progress, using the color sketch as the basis but adding shapes and colors as the painting matures.

The different hues of yellow interact in the main subject and reappear in the background like fine lacework. Shapes along the edges and corners are changing, and there is harmony of colors, of lights and darks, and of crispness and softness. The focus is on the main subject. The painting has depth and a sharply defined foreground in contrast to a soft dark background. This painting is finished and much to my liking.

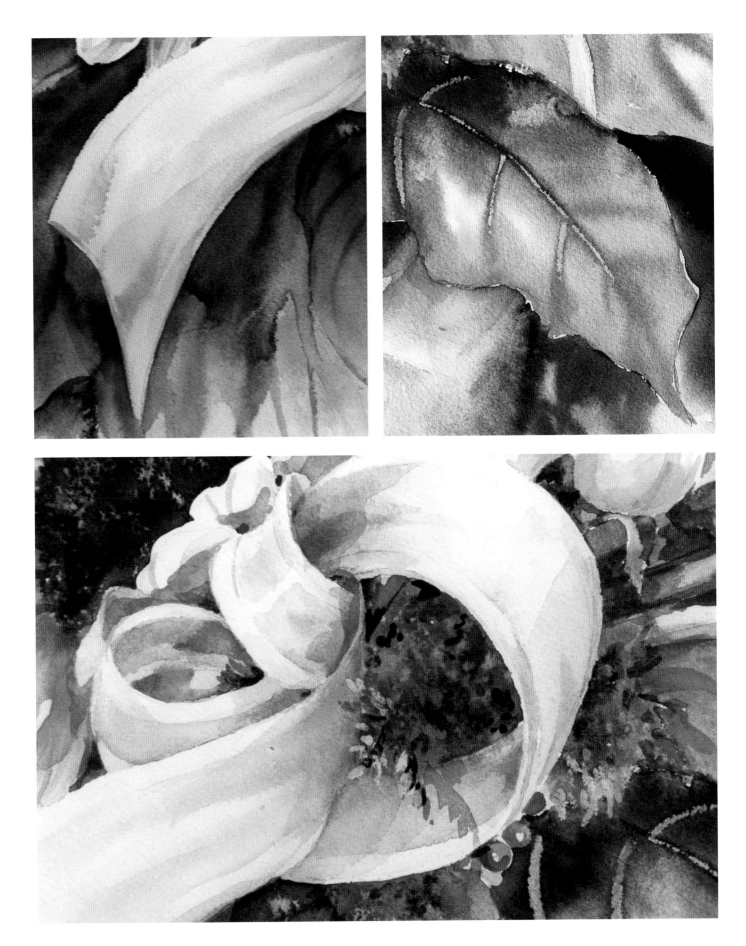

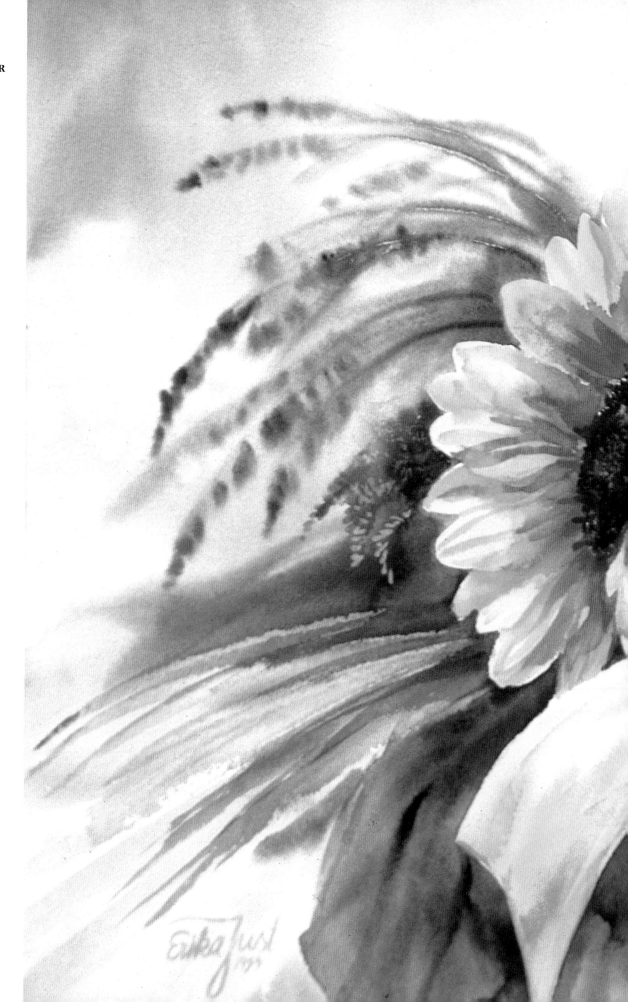

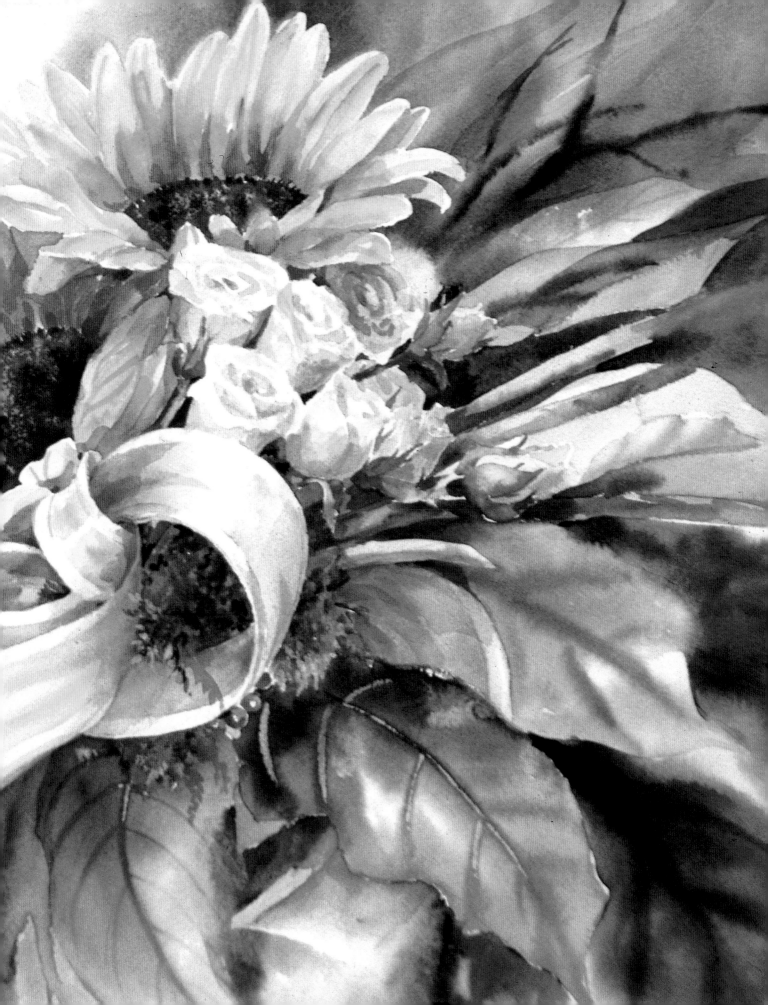

At the Edge of a Brook

Driving through the Austrian Alps during my vacation, I passed through some beautiful, charming places. Because of a tight schedule I was just able to take photographs, although I would have much rather taken my paint and brushes out of the car to paint what I saw right then and there. Little brooks with lush vegetation along their edges looked intriguing and the bright yellow flowers in front of some dark green moss attracted my special attention.

During the following winter I remembered my photographs from last year's trip. Since I did not want to reproduce the snapshots in the form of a painting but rather wanted to re-create the atmosphere and feeling of the place, I put several photographs in front of me and let myself get inspired. After the painting was finished it showed the edge of a brook that does not really exist but insead is a medley of many impressions.

● STEP 1

I decided to skip making pencil sketches and started with color sketches right away. Drawing different rectangles of various sizes, I tried to figure out where to place the dark mossy tree trunk and how I could show the flowers to their best advantage. Doing these little thumbnail color sketches was quite enjoyable, and brought back the mood of last year's trip.

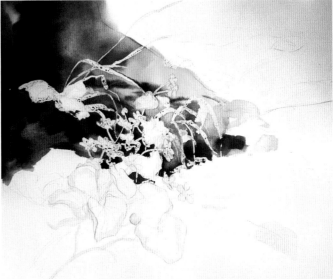

● STEP 2

The drawing was quickly done. I sketched a few blades of grass beside the flowers and some fallen beech leaves along the edge of the water. Grateful for its existence, I used masking fluid to overlay the blossoms, the edges of the leaves, and the blades of grass. On second thought, I added a few partially submerged beech leaves in the area where the water would be and covered those with masking fluid as well. To paint the moss on the tree trunk and on the rocks requires some freedom of movement.

This time, I planned to use only a limited palette of sap green, French ultramarine blue, Prussian blue, burnt sienna, Vandyke brown, aureolin yellow, and permanent red.

● STEP 3

To cover a relatively large area with very dark paint requires more time than laying in a transparent wash. To be able to dip my brush into soft paint, rather than taking up pigment from a dried-out well, I put water into the wells of my palette before wetting the area of the trunk with plenty of water. Now I had time to lay the pigments onto the wet paper. Where the root is exposed to the sunshine, I used aureolin yellow with burnt sienna as an under-paint. Next I dipped my brush into French ultramarine blue and sap green and let it mingle on the paper instead of mixing it on the palette. I added a few touches of burnt sienna as an undercoat for the dead leaves, to be painted at a later stage. Salt will later absorb some of the darker overlying paint to let the yellow shine through and show the sunshine, which is falling through the trees.

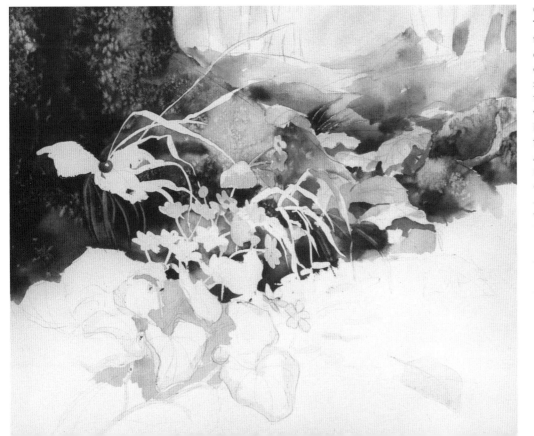

● STEP 4

To indicate the unevenness of the tree bark, I kept adding very dark pigments while leaving out some light areas. By now the shine of the wet paper started to disappear, indicating that it was time to apply the salt. While it was doing its work, I put a first wash onto the dry leaves. After pulling off some of the masking fluid, I added a touch of yellow to the flowers to achieve harmony in that first wash, indicating the distant landscape in the upper right-hand corner with a very delicate soft wash. The moss-covered rocks along the creek got the same treatment as the tree.

STEP 5 (RIGHT)

Repeating the colors of the foreground very loosely and in soft hues in the background, I made sure not to take away interest from my main subject. To balance the colors, I worked simultaneously on the blossoms, grass, and fallen leaves surrounding the moss-covered tree trunks.

STEP 6 (BELOW)

To achieve the beautiful rich dark for the shadows of the blossoms, I mixed aureolin yellow with permanent red. I painted the undersides of the blades of grass in a greenish yellow and the tops in a warm hue of burnt sienna and aureolin yellow. The shadows and veins of the dead leaves were painted with burnt sienna and permanent red. To achieve the image of clear water where the root and rocks are submerged, I applied very transparent pigment with a very wet brush.

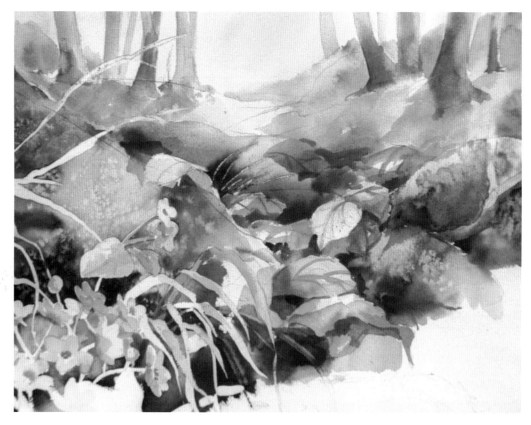

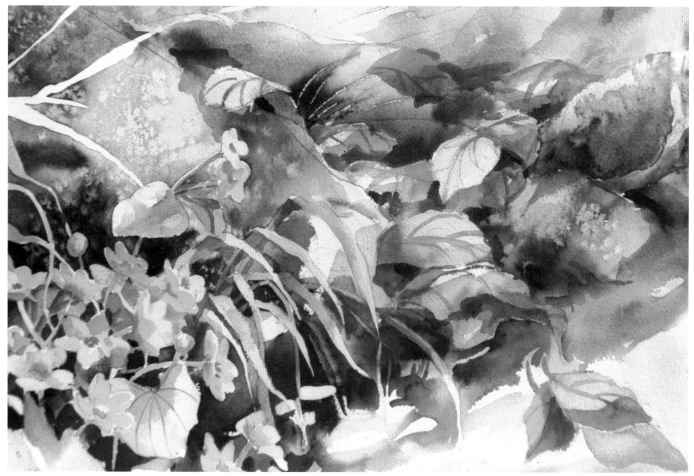

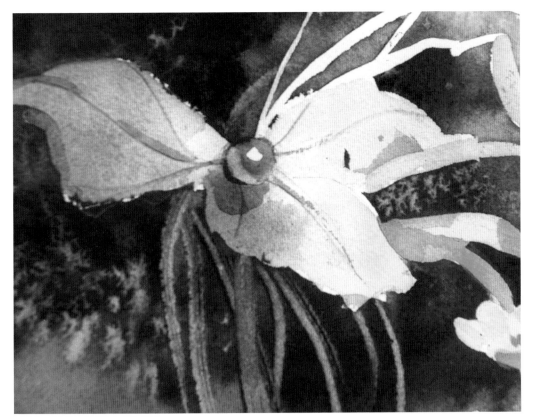

● STEP 7 (LEFT)
To contrast the cool color of the large dark-blue fruit of a white trillium against some warmer hues, I painted a few sunlit leaves next to it.

● STEP 8 (BELOW)
Painting the plant with the yellow blossoms as light and bright as possible to emphasize my main subject, I used mainly sap green with aureolin yellow; for the darker greens I used some French ultramarine blue. Overlaying some transparent washes on dry paper, I created the luminosity of the clear water.

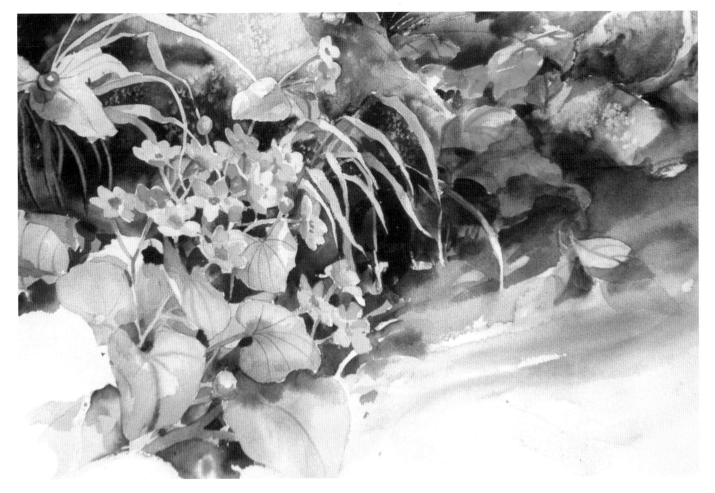

● STEP 9 (TOP), DETAIL (ABOVE)

Sprinkling some salt on the rock, I showed a growth of moss on the left-hand side of the plant. Removing the remaining masking fluid from the leaf in the water, I gave it a first wash on its submerged side. Continuing with some more glazes over the water and over the partially submerged plant leaves, I finished with dark blue-green pigments to indicate the deeper water under the tree. Finishing the leaves, I drew their veins with the rigger and touched up the twig that sticks out of the water. Looking at the finished painting, I could almost feel the atmosphere of the imaginary little brook with its trout hiding under the rocks.

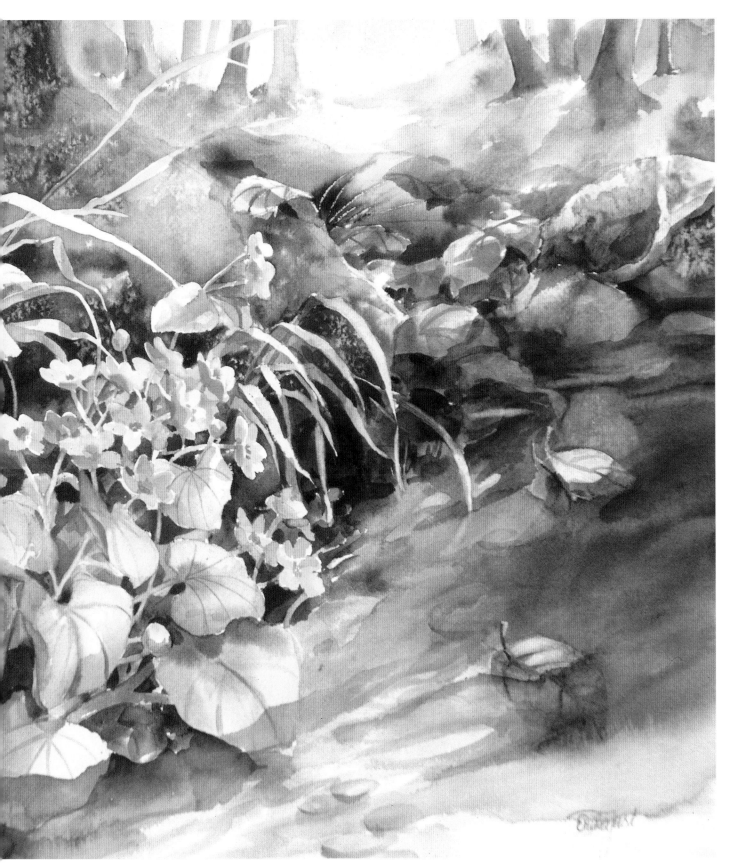

AT THE EDGE OF A BROOK
19" × 21" (48 × 53 cm).

After Christmas

Some time after Christmas, when the snow starts melting, attractive white Christ roses lift their little heads out of the snow. After a heavy winter it is delightful to observe these messengers of a spring that has not arrived quite yet.

Christ roses are frugal flowers growing in forests, on rocks, or out of a mat of moss, and it is surprising how they can bloom to full beauty with so little nourishment. Painting

them onsite is not an option because of the cold weather. Memorizing the settings in detail, I painted indoors. To paint from memory is a good exercise: Taking a close look at something, memorize what you see, then move into another room and draw it. If you need to jog your memory, go back and look again. After some practice, less and less return trips are needed.

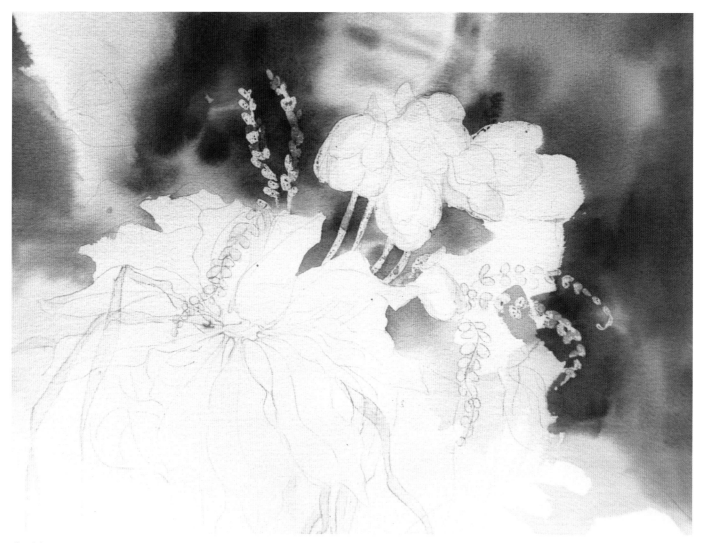

● STEP 1

This time, I skipped making thumbnail sketches because I knew exactly how I wanted to arrange the scenery. I positioned the white flowers in front of a large rock with light shining from above and dark shadows in the left and right background to accentuate the white blooms.

Using masking fluid, I covered the edges of the flowers, grass, and tiny ferns. Peacock blue helped me to achieve an icy atmosphere in the background. With a lot of water on the paper I let the colors float, leaving out some light spots to counterbalance adjacent dark areas that I created by adding pure color to the paper.

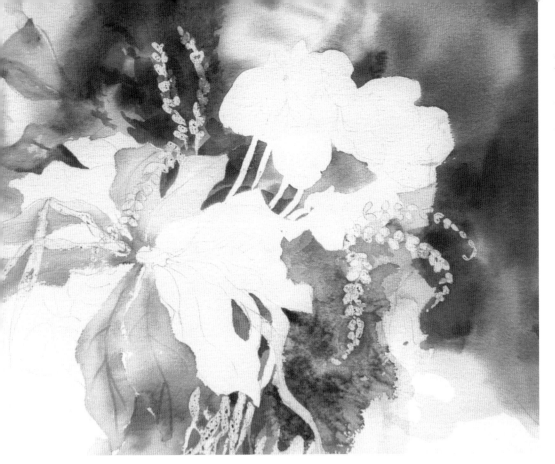

● STEP 2

The shapes of the darks in the background had come out good and strong. Painting the moss below the blooms on the right-hand side first, I laid down yellow pigment, which I overlaid with French ultramarine blue and some burnt sienna. Sprinkling some salt onto the wet area to take out some of the dark paint as it dried, I produced a nice image of moss. Into the upper left corner I glazed a few brown leaves with very little pigment on the brush. For the leaves of the Christ roses I used peacock blue, brown madder, and aureolin yellow, the same colors as in the background, and scraped some veins into the wet paint with the brush handle.

● STEP 3

Now it was time to remove the masking fluid from the Christ roses, grass, and fern. I finished the blue leaves with brown madder near the stem and verditer blue on the leaf. The dark leaves underneath the light ones give an impression of depth. For the grass I used yellow ochre and burnt sienna. Painting the yellow centers of the blossoms miraculously created flowers out of big white spots. The little ferns were treated the same way as the leaves.

STEP 4

To define the Christ roses illuminated by the sun, I used a warm mixture of brown madder and thin, diluted sap green, which produced a wonderful warm gray. For the shadows on some of the flowers I used sap green only. I added a few brown leaves on the left-hand side and did some more work on the grass.

Stepping back to check the darks in the painting, I decided to add a strong dark background behind the grass and leaves in the lower left-hand corner.

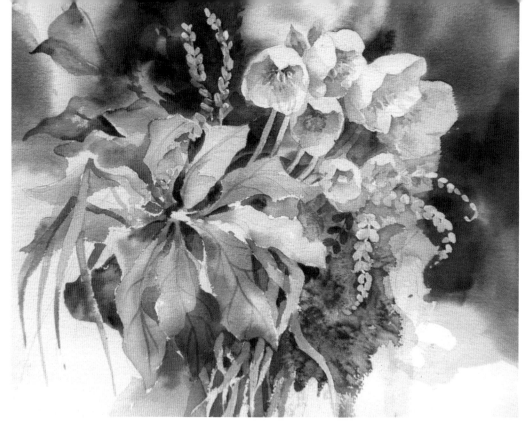

STEP 5, DETAIL OF THE FINISHED PAINTING

To bring out the main subject, the background of a painting is very important. A light colored subject requires a dark background, and cool colors should be set against warm ones as I did in this painting. I used burnt sienna to complement the cool blue leaves, darkened the background in the lower left-hand corner, and gave it the same treatment as the moss on the right: I wetted the paper and added sap green, verditer blue, French ultramarine blue, and sepia, letting them mingle on the paper. As the shine was nearly gone I added some salt, but very little because although I wanted to repeat what I had done on the right-hand side, I wanted this to be a variation on the theme. Finally, I added further depth to the painting by placing a few small dark spots among the various shapes of leaves and grass.

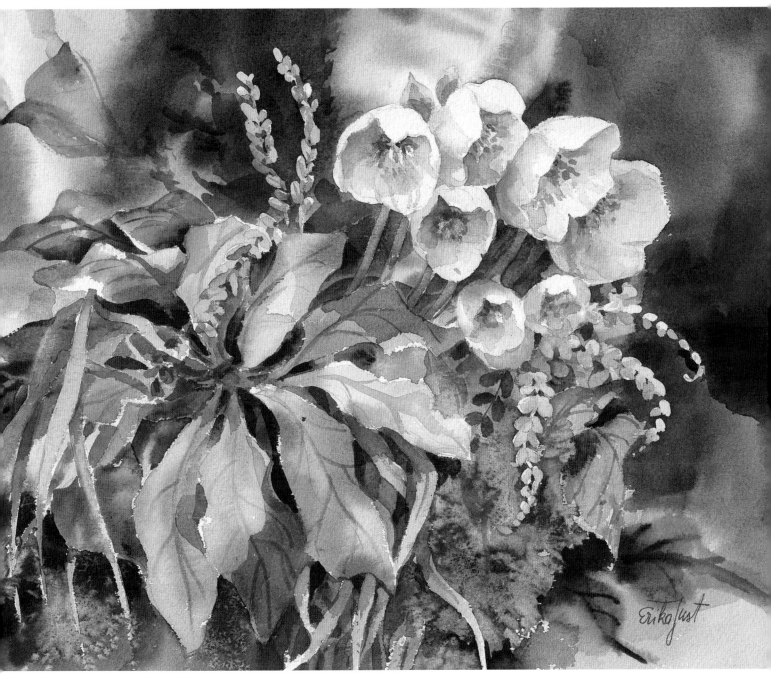

AFTER CHRISTMAS
12" × 14" (30 × 36 cm).

Index

Note: Entries in italics are titles of works; page numbers in italics indicate illustrations.

Accents, 69
After Christmas, 140–143
Angels Trumpets, 33
Arches paper, 16
A Short Visit, 6
A Summer Nosegay, 80–81
A Summer Nosegay #2, 34–35
A Touch of Spring, 53
At the Edge of a Brook, 134–139
Azaleas, *11*

Backlighting, 72
Beauty of Little Things, 82–87
Beginning a painting, 64–65
Bellflowers and Phlox, 60
Bell-shaped flowers, 59
Birthday Carnations, 12–13
Bleeding Heart, 60
Blending colors, 26–30. *see also* color theory
Bluebonnets and Indian Paintbrushes, 7
Bouquet with Blue Ribbon, 5, 59
Bouquet with Pink Roses, 32
Brushes, 14–15

Canterbury Bells, 59
Caravaggio, 69
Cattleyas and Phalaenopsis, 47
Chiaroscuro technique, 69–71
Chinese Peonies, 36, 40–41
Clematis "Nelly Moser," 104–109
Cold-pressed paper, 16, 18
Colors. *see* color theory
Color star, 22, 23–24
Color theory, 21–32
Complementary colors, 22–23
Completion of a painting, 78

Composition, principles of, 74–77
Conventional painting, 38–39
Cool colors, 31

Dahlia, frontispiece
Dahlias, *88–91*
Daisies, *58, 59, 61*
Daisies and Friends, 58
Decay Begets Life, 62
Delphinium "Blue Beauty," 60
Design principles, 74–77
Direct painting, 38–39

Edges and lines, 40–44, 50, 76
Emphasis. *see* point of interest

Fabriano paper, 16
Ferns, 63
Finishing a painting, 78
Fireweed, 8
Flower of Gods, Flower of Love, 126–133
Flower shapes, 45, 59–61. *see also* specific flowers
Flowers of the Forest, 67
For the Young Bride, 31
Fuzzy lines, 44

Gladiolas, 65, 72, 78, *110–113*
Glass Bowl with Roses, 19
Glazing, 54
Goldenrod, 45
Grass, 63
Ground covers, 63

Hard edges, 42–43
Hibiscus, 36
Hidden Treasures, 33, 69
Hide and Seek, 73
High key paintings, 69–70
Holbein (company), 21
Hot-pressed paper, 16–17
Hues, 21

I Dream of Summer, 70
Inspiration
 nature as, 58, 82
 photographs as, 68, 134
Intensity, 21

Irises, 65, 114–119
Ivy, 63

Klimt, Gustav, 69
Kolinsky brushes, 14

Leaves, 62–63, 95
Lighting, 69–72
Lilacs, 45
Lilies, *52,* 78
Lilies of the Field, 52, 72
Lilies of the Valley, 49
Lilies of the Valley in a Round Vase, 55
Lines and edges, 40–44, 50, 76
Little Blue Treasure, 18
Lost-and-found edges, 40–41, 76
Low key paintings, 69–70

Madonna of the Meadow (Raphael), 74
Magnolias, *33, 42–43*
Masking fluid, 48, 83
Middle value paintings, 69, 71
Mixing colors, 21–30. *see also* color theory
Moss, 37
My Studio, 68

Nasturtium, 16, 72, *120–125*
Nature as inspiration, 58, 82

Orchids, *46–47, 60–61,* 76
Orchids from Singapore, 76
Outdoor sketching tools, 66

Painting techniques
 chiaroscuro, 69–71
 conventional (direct), 38–39
 edges, 40–44, 50, 76
 fuzzy lines, 44
 glazing, 54
 masking, 48
 petals, 53
 salt, 37, 45–47, 83–84, 135, 138, 141–142
 scraping, 50, 89, 122
 stenciling, 52
 wet-in-wet, 36–37

Paints, 21
Palettes, 20–21
Pansies and Daisies, 2–3, 59
Pansy and Daisies, 7, 61
Paper, 16–19
Paphiopedilum Philippinense Orchid, 60
Parrot Tulips, 38–39
Peonies, *40–41*
Petals, 53
Phlox, *60–61*
Photographs as inspiration, 68, 134
Pietà, The (Michelangelo), *74*
Pike, John, 20
Pink Cattleya, 46, 69
Pink Dahlias, 88–91
Pink Magnolias, 42, 43
Pink Sensations, 50–51
Point of interest, 72–73, 75
Poppies, 25
Primary colors, 22–23
Primary Colors, 73
Pussy willow, 63

Queen Elizabeth, 10

Red Gladiolas and Lilies, 78
Rembrandt Harmenszoon van Rijn, 69
Rigger brushes, 15
Roses, *10, 19, 32,* 63, *79, 126–133, 140–143*
Rough paper, 16, *19*

Salt technique
 basics of, 45–47
 in demonstration projects, 37, 83–84, 135, 138, 141–142
Sargent, John Singer, 69
Schminke (company), 21
Scraping technique, 50, 89, 122
Secondary colors, 22
Sensations (flower), *50*
Shapes of flowers, 45, 59–61. *see also* specific flowers
Sketching
 in demonstration projects, 82, 88, 92, 104, 110–111, 126
 purpose of, 65–66

Silver Dollar, 56–57
Snapdragon, 17
Snapdragons, 9
Snowflakes, 45
Spring is Upon Us, 72
Stars, 45
Starting a painting, 64–65
Stencils, 52
Sunflowers, 92–97, 126–133
Symbol of Love, 74, 79
Symmetry, 76

Techniques. *see* painting techniques
Temperature of colors, 21, 31
Tertiary colors, 22
Tools
 brushes, 14–15
 brush handles, 50
 masking fluid, 48
 paints, 21
 palettes, 20–21
 sketching, 66
 stencils, 52
Translucency, 53
Transparency, 54
Triangular structure, 74
Trillium, *62*
Trumpet-shaped flowers, 59
Tulips, *38–39, 98–103*
Tulips from Amsterdam, 98–103

Value limitations, 69–71
Value of colors, 21

Warm colors, 21, 31
Water Lily Pond, 71
Wet-in-wet technique, 36–37
White Azaleas, 11
White Gladiolas, 65, 72, 110–113
White Lilies, 69, 70
White Magnolias, 33
Whitney, Ed, 36
Winsor & Newton (company), 14–15, 21, 48
Wood, colors of, 37
Working Outdoors, 67

Zinnias and Snapdragon, 9